LLANDUDNO

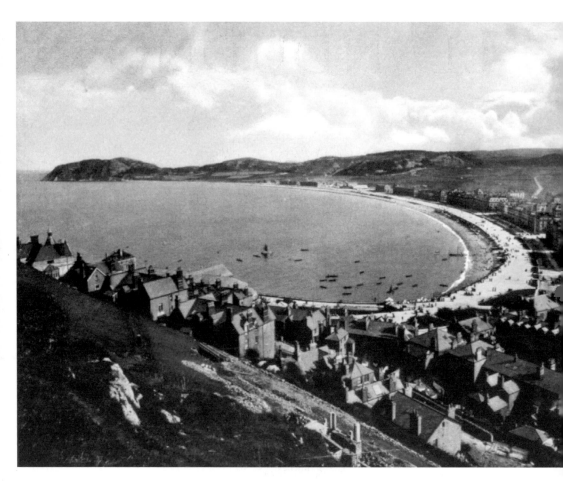

Llandudno Bay from the Great Orme, *c*. 1910.

BRITAIN IN OLD PHOTOGRAPHS

LLANDUDNO

JIM ROBERTS

Dedicated to Sheila, Mum, Cariad, and all photographers of the past
who have unknowingly contributed to this book.

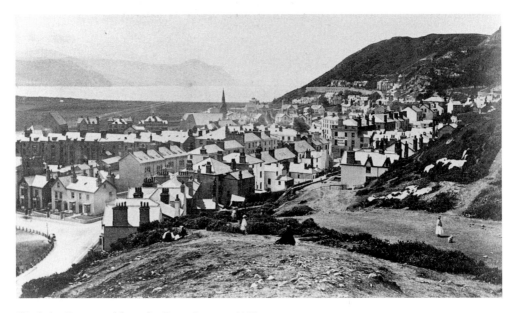

Llandudno Bay viewed from the Great Orme, *c.* 1880.

First published in 1997
This edition first published in 2009

The History Press
The Mill, Brimscombe Port
Stroud, Gloucestershire, GL5 2QG
www.thehistorypress.co.uk

© Jim Roberts, 1997, 2001, 2009

The right of Jim Roberts to be identified as
the Author of this work has been asserted in accordance
with the Copyrights, Designs and Patents Act 1988.

British Library Cataloguing in Publication Data.
A catalogue record for this book is available from the British Library.

ISBN 978 0 7524 5059 9

Typesetting and origination by The History Press
Printed in Great Britain

CONTENTS

INTRODUCTION

One hundred and fifty years ago Llandudno was a cluster of cottages and huts in and around the shoulder of the Great Orme. The population of approximately a thousand earned a precarious living from fishing, mining and farming. The present town, with a population of 18,500, developed on the Creuddyn Peninsula between the two Ormes and earns its living largely from the demands for tourist and leisure provision.

During Victorian and Edwardian times it was considered healthy to immerse the body in mineral and salt-impregnated water. The practice of 'bathing' led to the development of spa towns and seaside health resorts. It was also considered good to stop working for a period of time each year and go away for a change of air and environment. The holiday at the seaside was the result.

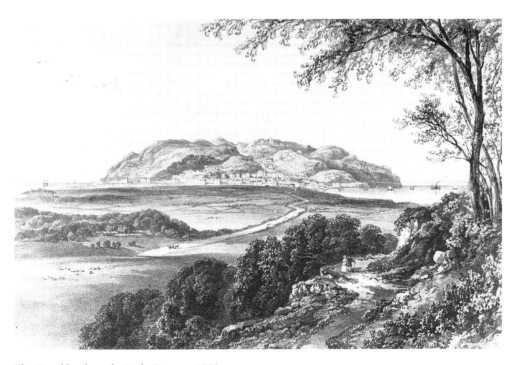

The Creuddyn from the Little Orme, *c.* 1850.

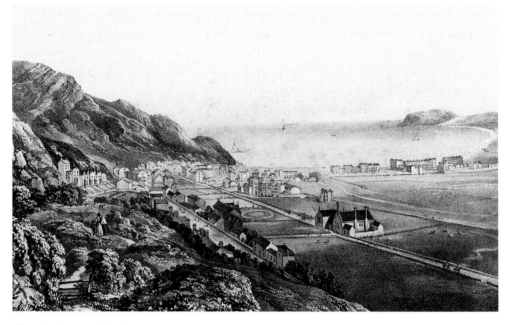

The town begins to develop, *c.* 1860.

Llandudno with its spectacular sweep of bay, its magnificent scenery and its two beaches was an area ripe for development as a spa and seaside resort. Couple its natural features with the desire of landowners to put their land to profit-making non-agricultural use and you have a recipe for rapid development. Many people during the early part of the nineteenth century had commented upon Llandudno's possibilities as a resort, but it was Owen Williams, a Liverpool architect, who is usually credited with being the instigator of the town's subsequent development. In 1844 he visited the town with a friend who was attending a shareholders' meeting at Ty Gwyn mine. To kill time, Williams walked on to the Orme, and as he walked he became captivated by the scenery and convinced of the area's prospects as a resort. Over lunch at the King's Head public house he is reported as saying, 'What a beautiful place this is, and what a fine watering place this would make.' This remark was overheard by John Williams of Bodafon who wasted little time in conveying the message to Lord Mostyn. Letters were subsequently sent to Owen Williams, and, after a meeting in a fisherman's hut between Lord Mostyn, John Williams and Owen Williams, he was instructed to make a survey and draw up a plan for the development of the town.

The relationship between the Mostyn family and the development of the town is discussed very thoroughly in a recent publication, *Llandudno and the Mostyn Influence* by R. Ron Williams (Mostyn Estate and Llandudno and District Historical Society,

1996). The *History of Gwynedd* by Ian Skidmore suggests that by the introduction of the Eglwysbach, Llandudno and Llangystenin Acts into parliament in July 1843, by Edward Mostyn MP, the people of Llandudno were tricked out of their only asset. The act gave the land to its principal freeholders, and the largest beneficiary was the Hon. E.M. Lloyd Mostyn MP, the major landholder in the area, who received 832 acres of land. The Right Revd Christopher Bethel, the Bishop of Bangor, received 18 acres of prime land as a reward for his support. It is not difficult to imagine what kind of response would be evoked today were such an event to occur.

The enclosure happened because the law of the land allowed it to happen. Between 1760 and 1844, six million acres of open land, pasture and common land were parcelled up and given to the rich and powerful, and parliament, whose members were the rich and powerful, passed over 4,000 acts to allow this. Violent incidents did occur in many places but there is no record of any such occurrence in Llandudno.

On 29 August 1849, in Plas Mawr, Conway, 176 lots of land were auctioned. This covered 27 acres of the Creuddyn, and they were offered on seventy-five year leases. At a give-away price of 6*d* a square yard there were initially very few bidders. The few plots sold were in the Mostyn Street and Church Walks areas, prime sites in the developing town. From these slow beginnings the town began to develop at an amazingly rapid rate, under the watchful eye and with the guidance of a Committee of Improvement Commissioners.

The Llandudno Improvement Act of 1854 was concerned with all aspects of the orderly growth of the developing town. Twenty commissioners were appointed under the chairmanship of Lord Mostyn. They were responsible for the provision of highways, drainage, sewage and waste disposal, water and gas. They regulated building, and new street development, and were responsible for law and order. They continued their work for about fifty years, and eventually handed over to the new Urban Council in January 1895.

Observers of the development in those early years would have been amazed at the rapidity of the town's growth. The present town with its wide streets and pleasing buildings came about because of the control exercised by the commissioners.

In 1853, the St George's Harbour and Railway Company had been given parliamentary approval to turn Llandudno into the main port of North Wales. It would deal with the Irish Packet traffic, and the export of coal from the Denbighshire coalfield. The town would be renamed Port Wrexham. The development would consist of 'Breakwaters, piers, jetties, lighthouses and other works for the safe and convenient passage of ships and other vessels into and out of port'. Instead of the beautiful sweep of the bay with its splendid promenade the Llandudno waterfront

would consist of 'Walls, docks, slips, locks, reservoirs, quays, wharfs, moorings, staiths, drops, landing places and other buildings and works, together with a communication by railway to the port and its works'. A railway would have run through the centre of the town and emerged in the port in what is now Prince Edward Square.

Work began in anticipation of approval for the plan. The first pier was built in 1858, and a 3 mile branch line was laid from Llandudno Junction to Llandudno. The pier existed for only one year. The Great Storm of 1859 (which resulted in the tragic loss of the *Royal Charter* off Moelfre, Anglesey) caused irreparable damage to the pier.

The branch line, greatly improved, still exists, but the loss of the pier together with major administrative problems led to the port development scheme going to the rival bidders, the main line Chester and Holyhead Railway Company, and Holyhead became the main North Wales port.

The town emerged from village status in 1846, its population struggling to make a living from fishing, farming and a rapidly declining copper and lead mining industry. By carefully harnessing its natural assets, and by keeping a watchful eye on those who would despoil its environment and charm, it has today become one of the loveliest seaside resorts in the country. Thousands of people visit the town each week and the town prospers in proportion as it caters for their needs.

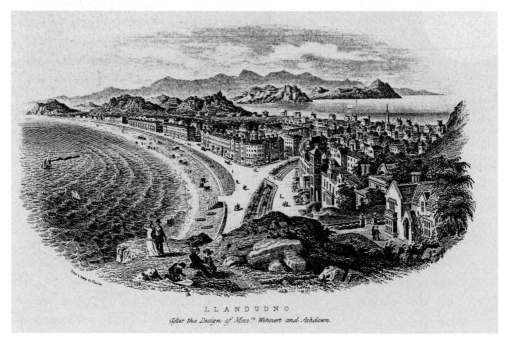

L L A N D U D N O
After the Design of Mess.rs Wehnert and Ashdown.

'Port Wrexham' with proposed railway to the pier. The illustration is after the design of Wehnert and Ashdown.

SECTION ONE

THE GREAT ORME

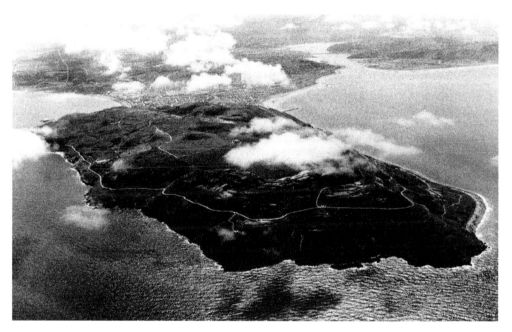

The Great Orme's Head is Llandudno's most distinctive feature. It is 1 mile wide, stretches out into the sea for 2 miles, and its highest point is 679 ft above sea level. It is an area of great natural beauty and has important historical significance. Beyond the Orme in this view both shores and the shelf that connects it to the mainland can be seen. The town is built on this shelf. The Marine Drive, the lighthouse and St Tudno's church are visible. The summit buildings are obscured by cloud.

The heads of the two Ormes rising from the mist when viewed from the sea resemble the heads of sea serpents, and the Vikings who made the Irish Sea their happy hunting grounds called them 'orm', which translated means worm or serpent. The Worm's Head on the Gower Peninsula has the same name origin. The Welsh name for the Great Orme is 'Gogarth'.

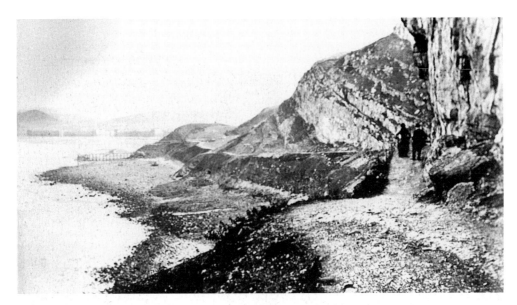

Before the Marine Drive was built a footpath existed, known as Cust's Path. Cust was a lawyer and a Mostyn Estate trustee who instigated the building of the path. In this photograph of Cust's Path two people can be seen rounding the spur on the right. The path was very dangerous with precipitous drops to the sea. W.E. Gladstone, the prime minister, walked the path to visit his friend Dean Liddell at Pen Morfa on the West Shore. In places the prospect was so frightening that the prime minister had to be blindfolded and led by the hand.

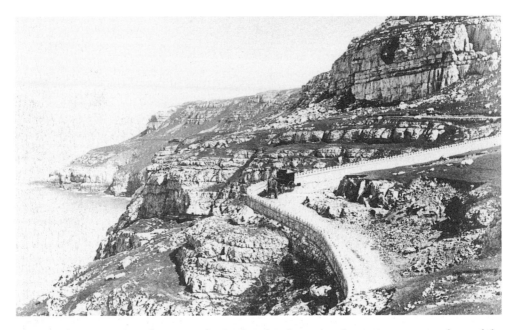

In 1873 parliamentary approval was given for Cust's Path to be converted into a permanent road around the Orme. Work began in 1875. The Drive required the removal of many thousands of tons of rock to provide a level surface for the subsequent road. Unfortunately during the clearing several megalithic tombs were destroyed.

MARINE DRIVE, LLANDUDNO.

In 1897 Llandudno town council purchased the Drive from the Marine Drive Company for a sum of around £11,000. Pedestrian tolls were abolished in 1930, but a vehicle toll still exists.

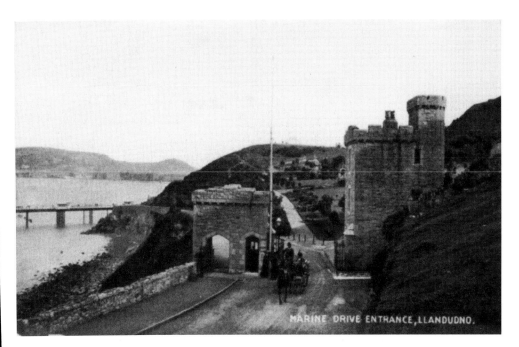

MARINE DRIVE ENTRANCE, LLANDUDNO.

This photograph shows the Marine Drive entrance from the Happy Valley end. At each end of the Drive stands a toll house. The distance between the gates is 4 ½ miles.

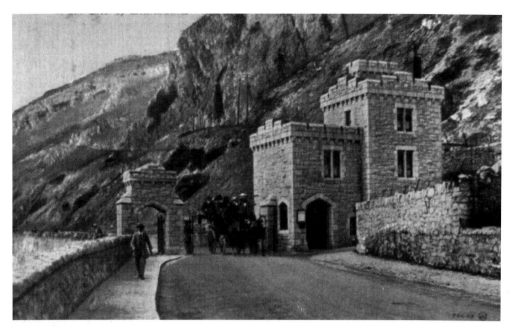

This is the toll gate on the West Shore, c. 1910. The travellers in this carriage probably started their journey in Prince Edward's Square and will return via Gloddaeth Avenue, a round trip of 6 miles.

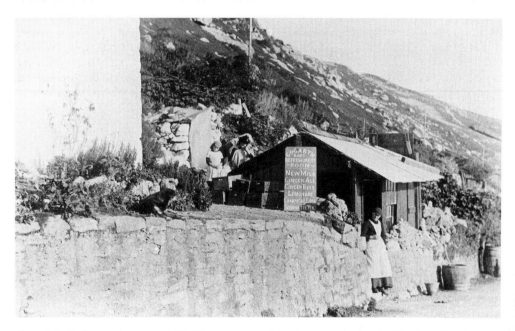

Gogarth Refreshment Rooms, c. 1890. The proprietor, Mrs Jones, stands outside. The fare offered on the board is 'New Milk, Ginger Ale, Ginger Beer, Lemonade, Champagne Cider, Soda Water and Tea'. The Marine Drive is, as yet, unmetalled and the ride around the Orme in the primitively sprung carriages would have been rather uncomfortable, making this stop all the more welcome.

Mrs Jones and family of the Gogarth Refreshment Rooms pose in the doorway of their cottage, *c.* 1890. It was near this spot that one of Llandudno's cave dwellers lived for many years. She was named Miriam Jones and she lived in a cave which was destroyed when the Marine Drive was constructed. She is reputed to have brought up thirteen children in the cave. Her husband Isaac Jones was an Anglesey man from Amlwch who came to Llandudno to work in the copper mines. He constructed wings from seagulls' feathers on a wicker framework and attempted to do an Icarus from the side of the Orme. He survived with broken limbs and was nursed back to health by his loving wife. 'Miriam of the Cave' died in Llandudno in 1910 aged ninety-one. The descendants of the family are known as 'R'ogo' (literally 'from the cave') to this day. A memorial to Edward Codey Jones (Ted-yr-Ogo) can be found on the promenade near the Cenotaph. He died in 1965.

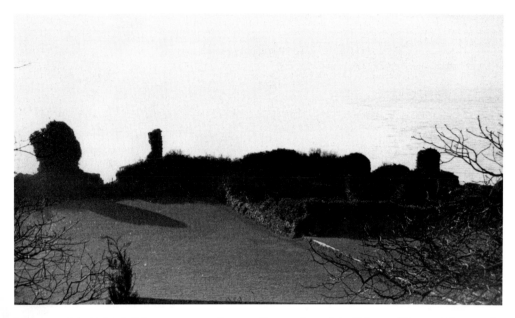

The ruins of the Bishop's Palace were once the magnificent palace of the Bishops of Bangor. The ruins lie at the foot of the south-western slopes of the Great Orme and are visible seaward from Marine Drive. The Palace has its origins in the thirteenth century and was given by Edward I to Bishop Anian in 1279 as a reward for christening his son, the future Edward II, who was born in Caernarfon. At first sight it would appear that the site was badly chosen since most of the building has collapsed into the eroding sea, but evidence from early maps suggests that even in the eighteenth century the palace was at least a mile inland; the land has been lost in the intervening years because of the cutting action of the River Conway. The palace is said to have been burned and destroyed by Owain Glyndwr in the first decade of the fifteenth century. Leland, who visited it in 1536, described it as 'almost clene down'. The site was sold by the Church in 1894 and a large private house was built on higher ground above the ruin. This has now been enlarged and serves as a convalescent home.

This recent photograph shows the Monks' Path traversing the side of the Great Orme. It ran from the Bishop's Palace (Gogarth Abbey) to St Tudno's church on the other side of the Orme. The passage of so many holy feet is said to have blessed it with everlasting greenness; it is more likely that the passage of so many sheep's feet and what the sheep have deposited over the years assure its verdancy.

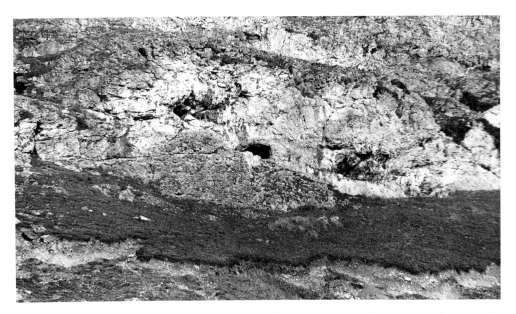

The cave centrally placed in this photograph is known as the Bear's Cave (Ogof Arth). It was the home of a Llandudno troglodyte named John Stephens, who claimed to have lived there for fourteen years when he was questioned by a newspaper reporter in 1862. More recently the cave was occupied by one Gwilym Hughes who lived there for several years. He was evicted from the cave by Llandudno Council and housed in one of their flats.

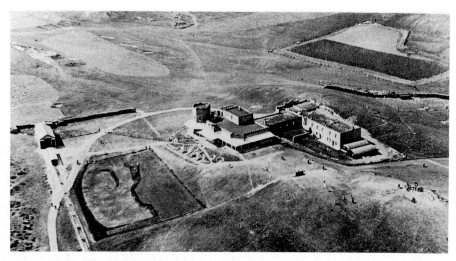

The Summit Hotel, seen here in the 1920s, was built by Mr Thomas McDonald as a telegraph hotel in 1909. It was a relay station for shipping signals from Point Linas to Merseyside. An eighteen hole golf course adjoined the hotel. This rare aerial view shows several of the fairways and greens on the popular course. During the Second World War its obvious strategic position was realized and it became a radar station. In 1952 the world middleweight boxing champion, Randolph Turpin, bought it, owning it until 1961 when he sold it to Llandudno Council. The golf course no longer exists.

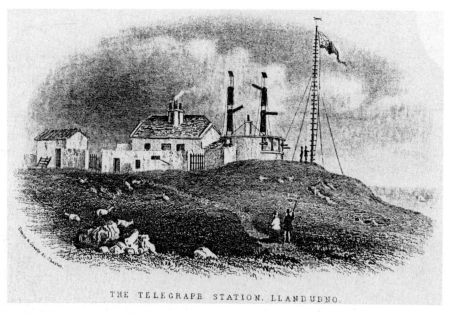

THE TELEGRAPH STATION, LLANDUDNO.

The semaphore station on the Great Orme was built in 1826 by the Liverpool Dock's trustees. Messages were relayed visually by a series of moving arms on masts. The Llandudno station was part of a linked system which stretched from Liverpool to Holyhead. The nearest in the link was a station on Puffin Island. A message would start at Holyhead and four or five minutes later it was received at Liverpool's Old Tower Building. The system was replaced by electricity in the 1840s and the station became part of the Summit Hotel.

The Great Orme lighthouse is situated on a precipice over 300 ft in height. The castle-like structure was built in 1862 by the Mersey Docks and Harbour Board, and for well over 100 years it guided ships in the busy sea lanes from the Mersey and the Dee. The light, a dioptic lamp of 18,000 candle power, shone from a tower in front of the building. The beams were visible 24 miles out to sea. On a clear night the light was visible from Snaefell, Isle of Man, 54 miles away.

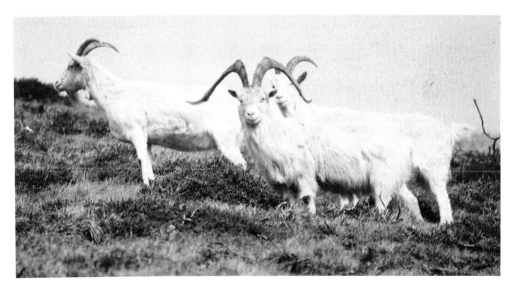

This recent photograph shows an interesting feature of the wildlife of the Great Orme, namely the white Kashmir goats which roam its slopes. The present herd is descended from a pair which were given to the young Queen Victoria by the Shah of Persia shortly after her coronation. Gifted to Sir Savage Mostyn from the Royal Windsor herd, their antecedents were freed on the Orme after breeding at Gloddaeth Hall. This breed of goat is the regimental mascot of the Royal Welch Fusiliers.

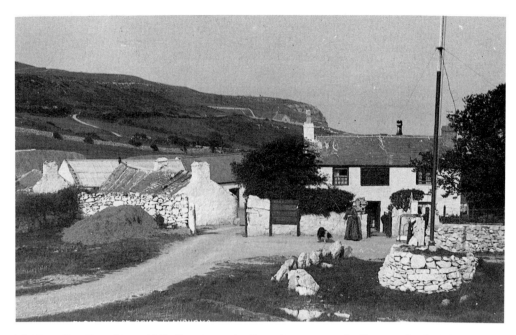

The Farm Inn, Great Orme, 1910. Farming on the Great Orme was, and still is, very hard work on rugged terrain with extremes of weather. At the Farm Inn extra income was earned by offering refreshment to the many tourists roaming the slopes of the Orme. The sign above the door reads: 'Mrs J. Roberts (Late) William Owen, Farm Inn, Great Ormes Head, licensed to sell Ale and Porter, Wines, Refreshments etc.' This farm is known as the 'Pink' Farm locally.

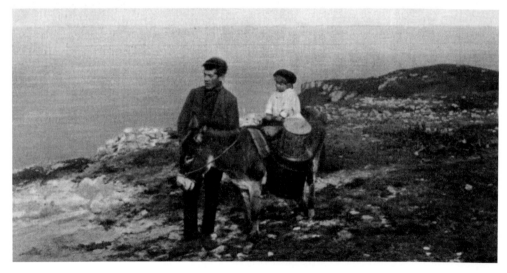

The Great Orme water carrier, c. 1910. He provided a very valuable service to the people living on the higher reaches of the Orme. The limestone rock is very porous and consequently any body of water that sets out to be a stream is soon absorbed. There is a lack of surface water and streams on the Orme, but lower down the water appears as springs where the soft limestone meets harder and older rock shelves.

Thomas Kendrick stands in front of his workshop in Ty Gwyn Road on the Great Orme, *c.* 1890. In 1879 Mr Kendrick, a stone polisher and ex-copper miner, in the course of extending his workshop removed a pile of rubble from the back of it. The rubble was a man-made wall which sealed off a cave. This cave, below Pen Dinas and above the town, yielded a treasure of great historical interest: the skeletons of four human beings of short stature with long skulls, believed to be of the Stone Age, the bones of the first primitive cow of 2,500 years ago, a necklace of teeth of various animals, a horse mandible, and two strange-looking teeth, about 3 in long, of the now extinct cave bear. These finds, with others, provide evidence of habitation from the Upper Paleolithic period (10000 BC) through to the New Stone Age. 'Beaker' pottery (2000 BC) and Bronze Age tools have been found in recent times on the slopes around Llandudno. In recent years there has been a great surge in interest in the Great Orme as an historical site. Organizations such as the Llandudno Historical Society, the Great Orme Exploration Society, and the work done at the copper mines have done a great deal to encourage and nurture this interest. This gives the lie to a recently published North Wales guide which describes Llandudno as a 'town with no history'!

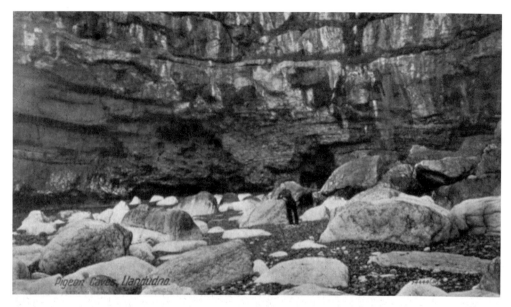

Pigeon's Cave, *c.* 1910. This is typical of the caves usually found in a headland of porous carboniferous limestone. In 1898 two boys uncovered gold ear-rings and some Late Bronze Age tools in the cave. These are now in the National Museum of Wales, Cardiff. It is at this point on the headland, where there is a natural shallow bay, that barges were loaded with limestone quarried from the Orme and transported for use in the construction of Conway's famous suspension bridge.

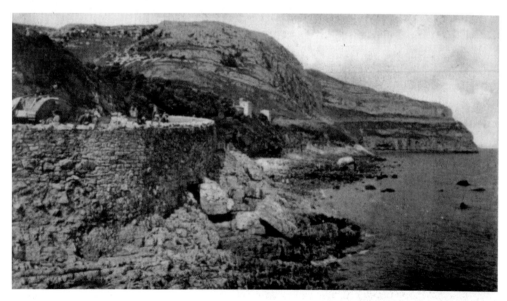

On the left of this photograph of 1925 there stands a First World War tank. This was presented to the town as a memorial of the war. After a nine year sojourn the council decided to remove it in 1931, despite the pomp and ceremony that had heralded its arrival. A Manchester scrap metal firm was charged the sum of £1 to get rid of it. Because of the strength of the leviathan it took the firm over a week to remove it.

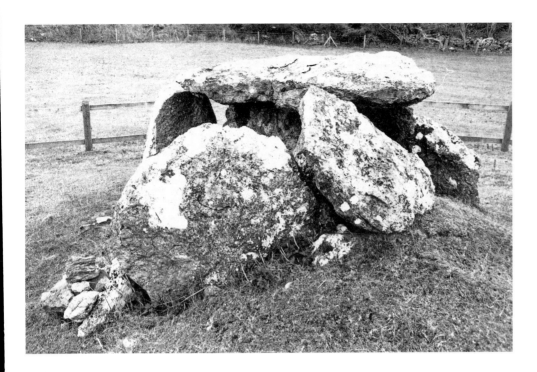

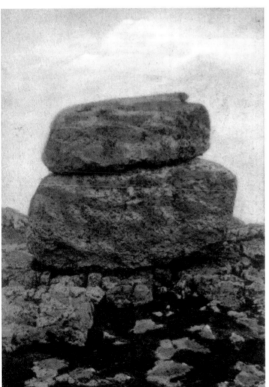

Above: A recent photograph of the Cromlech on the Great Orme. It is known as Llety-y-Filiast ('the kennel of the greyhound bitch'). It is the one remaining cromlech in the area after others were removed to construct Marine Drive and the Vaughan Street approach to the railway station. These Neolithic (2500 BC to 3500 BC) burial chambers were usually communal and could contain as many as fifty bodies.

Left: The 'Cottage Loaf' rock formation found on the Great Orme is an example of a glacial erratic. Towards the end of the ice ages large ice formations broke from the Scottish ice fields and floated down through the Irish Sea. They carried boulders with them which were deposited willy-nilly as the ice melted. The north corner of the Great Orme is littered with examples of these deposited stones, which look strangely out of place.

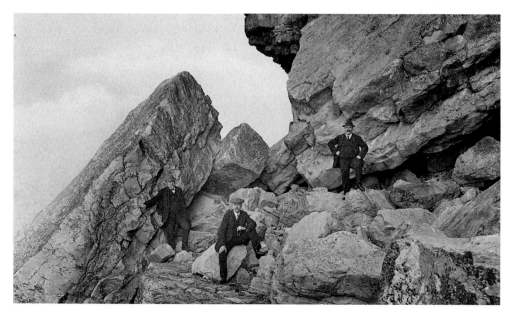

'Scrambling on the Rocks of The Great Orme', 1910. Serious rock climbing in the area has been taking place with increased interest since the late 1960s and '70s. Paul Williams in his book *Rock Climbing in Snowdonia* said that before this date 'the limestone cliffs were dismissed as negative backwaters, the preserve of the eccentric in pursuit of the esoteric . . .'. This has now changed, and Welsh limestone climbing has brought the North Wales coast into prominence as one of Britain's premier climbing areas.

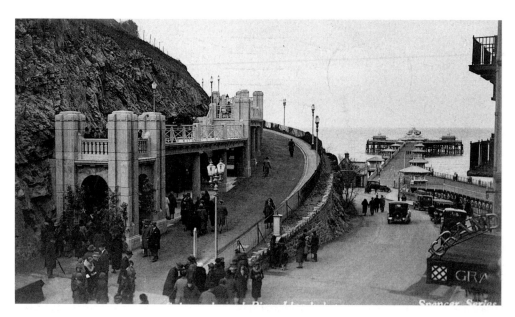

The Colonnade leading to Happy Valley was opened by Lord Mostyn on 31 March 1932. It is 185 yd long, 14 ft wide and cost £6,500 to build. The designer was G.A. Humphreys of Mostyn Estates, and it was built by W.T. Ward.

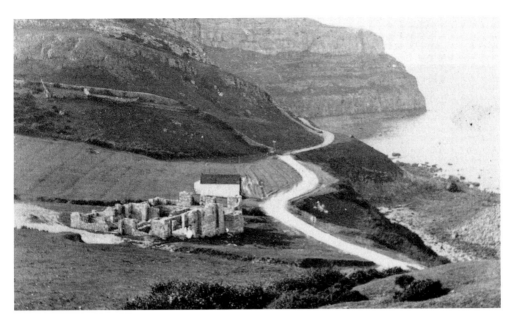

A very early view of Happy Valley. In the mid-1850s Robert Williams, the landlord of the George and Dragon, decided to build two houses in Happy Valley. The ground floors had been built when the Estate Authorities stepped in and had the work stopped, 'fearing the despoiling of the Happy Valley'. The rocks from the building were used to construct a rockery in the Valley. This photograph was taken before the Marine Drive was constructed, and we can see Cust's Path snaking into the distance.

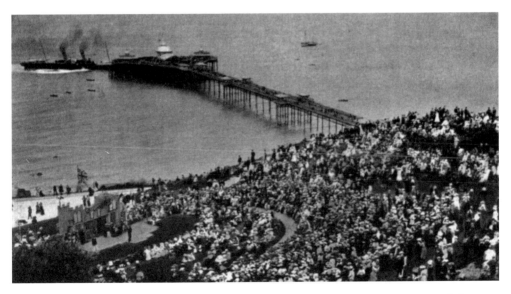

Happy Valley, 1910. To commemorate the Royal Jubilee in 1890 Lord Mostyn presented the town with Happy Valley. A canopied drinking fountain with a bronze bust of Queen Victoria was also presented. The Happy Valley was the place to be for entertainment. Churchill's Minstrels are entertaining a large crowd of holiday-makers and *La Marguerite* is docking at the pier.

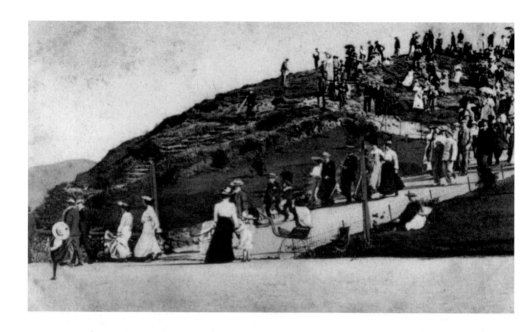

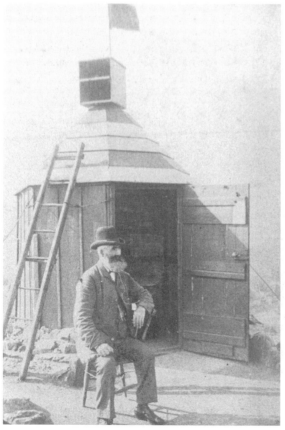

Above: The hill to the left of Happy Valley when viewed from the sea, 1910. It affords excellent views of the town and bay and was chosen as the site for a camera obscura, hence its name Camera Hill. This has nothing to do with modern photography, but the area does offer considerable attractions for today's photographer.

Left: This is the original camera obscura, built by Lot Williams in 1860. The obscura was a darkened room with a white surfaced table, which is a screen for scenic views projected from a series of lenses and mirrors in the roof turret. The scene changed when Lot climbed his ladder and revolved the turret. Local legend has it that he took an impish pleasure in finding courting couples and projecting their courting displays on to the table. The obscura was closed in 1964 and was burned to the ground by vandals in 1966. The present structure, which can be seen on the hill behind the Grand Hotel, was built by a local man who was anxious to preserve a tradition.

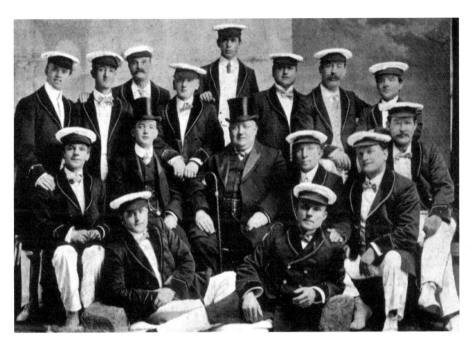

Perry and Allan's Happy Valley Minstrels, 1890s. Joe Perry, the senior partner, is the corpulent gentleman in the top hat. The slighter Alf Allan sits next to him. This is an advertising photograph and the reverse reads: 'Look out! They are coming! WHO? Perry's World Renowned Happy Valley Minstrels from Llandudno! Patronised by: The Right Hon. Lord Mostyn, Lady Mostyn, The Most Hon. The Marquis of Anglesey, The Right Hon. The Earl of Uxbridge, Lord Alexander Paget, Lady Whitworth etc. etc.'

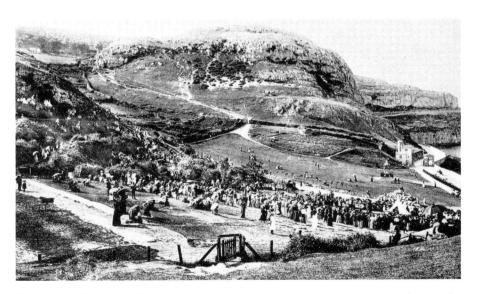

The Happy Valley, 1891. The earliest entertainers in the valley were a husband and wife team who used a tent as a changing room. Several of the early photographs of the area, such as this one, show the tent and the assembled crowd who are being entertained.

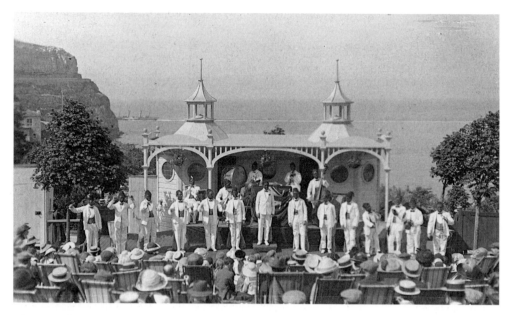

Churchill's Minstrels entertaining the crowds, as they did for over forty years before the First World War. Billy Churchill, who ran the concert party, appeared before the King and Queen in the first Royal Command Performance at the Palace Theatre, London on 1 July 1912.

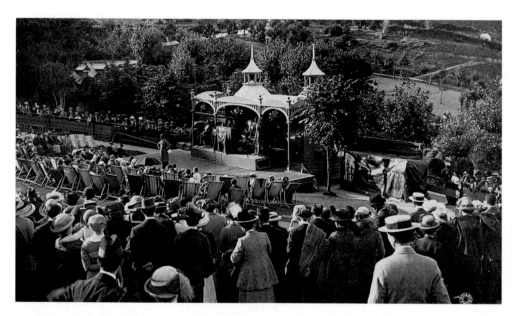

Another view of Churchill's Minstrels at the turn of the century. The paying audience sat on deck chairs during the performance. This view is from 'Edinburgh Hill', the standing area which was free. One of the performers passed among the crowd with a collection box periodically.

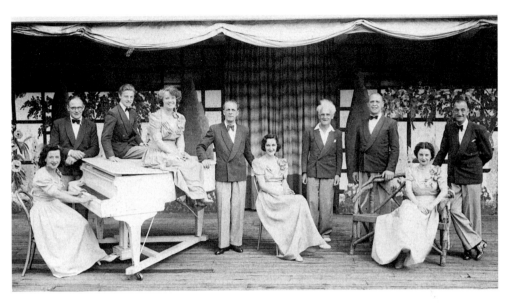

Another group who entertained the crowds in Happy Valley was the Charles Wade Concord Follies, pictured here in the years just before the Second World War. The artistes in the photograph are, from left to right, V. Raye, Bert Howard, Bob Desmond, Primrose Hill, Edgar Morris, Madge Ward, Desmond O'Neill, Charles Wade, Pat Dowes, and Bobbie Burns.

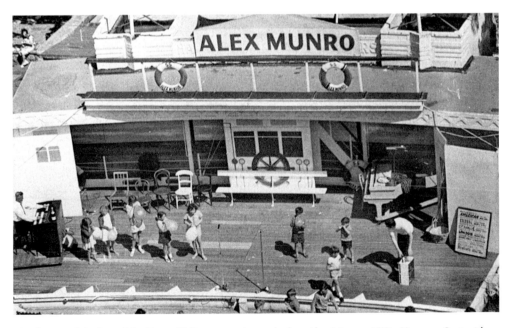

The theatre of the last of the Happy Valley entertainers, the late Alex Munro, 1971. He was a Scot with an acerbic wit, which he used to devastating effect on the crowds on Aberdeen Hill who were fleeing from the approaching collecting box. The photograph was taken from the cabin lift which opened in 1969, and is the longest passenger cable car in Britain. Sadly the theatre burned down and nothing has replaced it.

In an area known as Pen-y-Dinas above the Happy Valley there is a large stone known as Maen Sigl or Cryd Tudno (Tudno's Cradle). The stone is the famous rocking stone, which sadly no longer rocks. Pennant wrote in 1774: 'Near this place is a Maen Sigl, rocking stone, a great one, whose point of contact with the ground is so small as to make it moveable with the least touch.' It is said that St Tudno used the stone as a pulpit. Near the stone beneath the scrub there is clear evidence of the remains of an Iron Age hill fort, with a number of huts ranging from 4 to 7 yd in diameter.

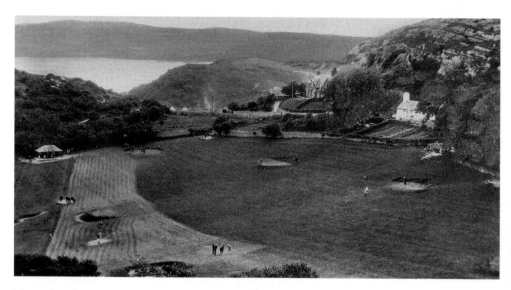

The pitch-and-putt course above the Happy Valley, c. 1920. An artificial ski slope and toboggan run now cover the golf course. The building on the right of the photograph is Wyddfyd Cottage, one of the oldest buildings in Llandudno. The present house dates from the early eighteenth century and marks the site of an ancient building dating from the thirteenth century. In this area copper mining was an important activity, and before the Enclosures Act an annual sheep fair was held nearby.

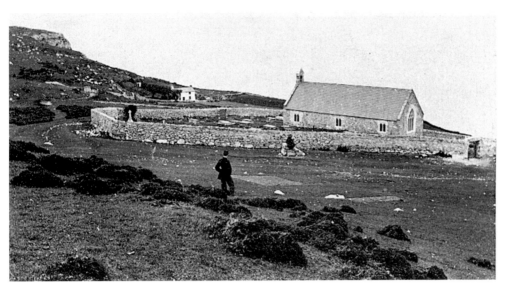

St Tudno's church, *c.* 1890. Llandudno means 'the enclosure of St Tudno'. He lived in the seventh century and was allegedly the son of a chieftain whose lands were swallowed by the sea. He is reputed to have had a magic whetstone, which blunted the weapons of the cowardly but sharpened the weapons of the brave. A church has existed here since before the year 1100. Parts of the present building have been dated as pre-1400.

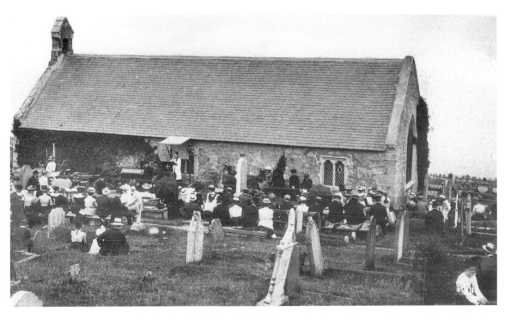

An open-air service at St Tudno's church, before 1912. Thousands of people over the years have flocked to open-air services at the church, and it would be difficult to imagine a more original and spectacular setting for an act of worship. Battered by gales and sweeping rain throughout the centuries, the church has occasionally been very badly damaged. In 1839 fierce gales ripped off the church roof, and it lay exposed to the elements and vandals for sixteen years before repairs were effected. Further restoration work was done in 1906.

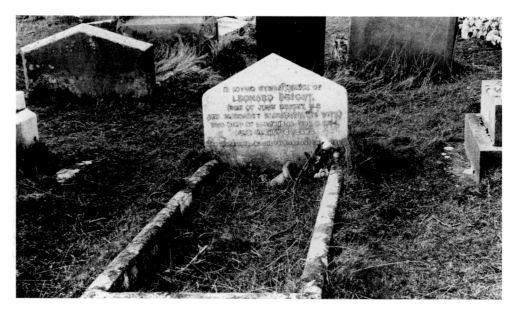

This is a recent photograph of the grave of Leonard Bright, the son of John Bright, the nineteenth-century radical politician. John Bright visited Llandudno frequently with his family, and tragically in 1864 his young son, Leonard, died of scarlet fever while in the town. Bright visited this grave annually thereafter until he himself died in 1889. Bright's lasting memorial is John Bright Grammar School (Ysgol John Bright) – he left a sum of money for the founding of the school and in 1907 it was opened. Archer Thompson, one of the most distinguished of British mountaineers, was appointed its first headmaster.

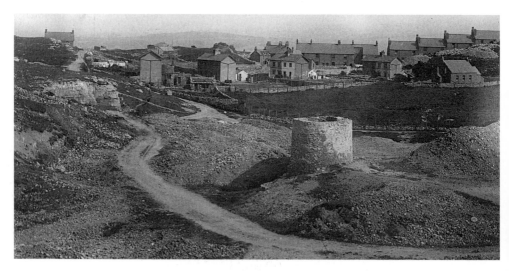

This is the mining village near the summit of the Great Orme. There is evidence of mining activity all around though actual mining had long ceased. The Romans mined ore here, and in the mid-nineteenth century, with fishing and farming, it was a major industry. Recent excavations have unearthed thousands of bone tools dating from the Bronze Age, some 3,700 years ago. The mines are unique in the world in that they had been worked almost continuously from about 2000 BC until little more than a century ago.

The miners worked a six day week in dreadful working conditions. They would have to descend by ladder, sometimes to depths of over 500 ft, to get to the ore face. Before the introduction of horse windlasses the ore had to be bagged at the face and carried to the surface on the backs of the miners. They earned between 11s and 17s a week depending on their status.

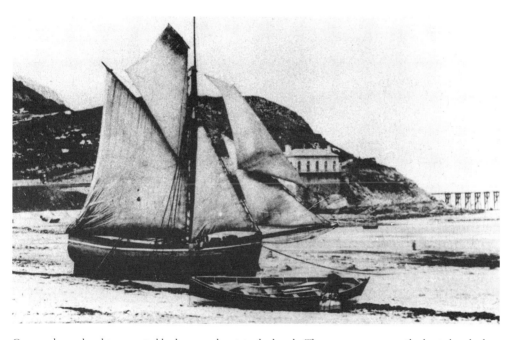

Ore was bagged and transported by horse and cart to the beach. There was no quay so the boats beached on the sand as the tide receded. They were loaded and left on the next tide for the ore to be smelted at Amlwch, Swansea, or Lancashire and the Midlands.

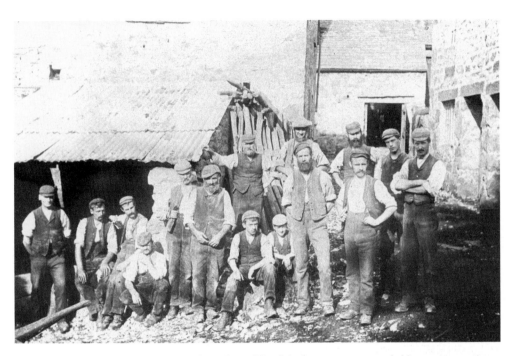

The building workers in this photograph from the middle of the last century are probably ex-copper miners. In 1848 mine working was on the decline: Ty Gwyn mine closed in 1856, Old mine in 1861 and in 1863 only twelve men were employed in the New mine. Fortunately, at this time the town was developing very rapidly, and there was a great deal of work available in the building and allied trades.

SECTION TWO

THE PIER

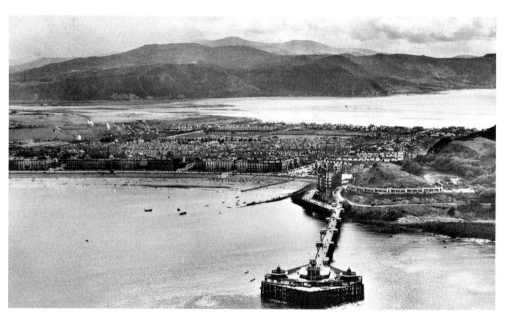

A view of the pier and town, 1945. The pier stretches an impressive 2,295 ft into the Irish Sea. It was opened in 1877, the second pier to have been built at this spot. The first was built in 1858 when Llandudno was a proposed coal and packet port. The Great Storm of 1859 which led to the loss of the Royal Charter *off Moelfre, Anglesey, also saw the end of the first pier.*

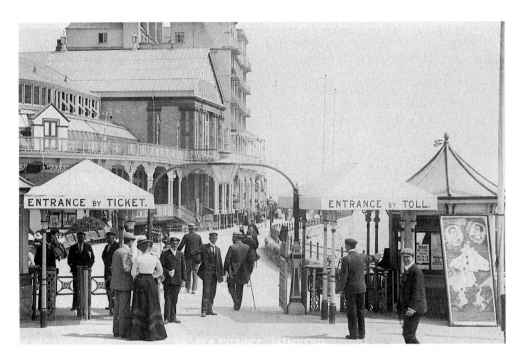

This photograph was probably taken in the first decade of this century, and is an interesting view of the pier entrance. Various attractions are advertised: the pierrots, trips in 'rubber wheeled' carriages to Bodnant Gardens and the obligatory steamer strip to Anglesey. The pier cost £25,000 to build so a toll of 4*d* was charged in the early years; this toll has now been abolished.

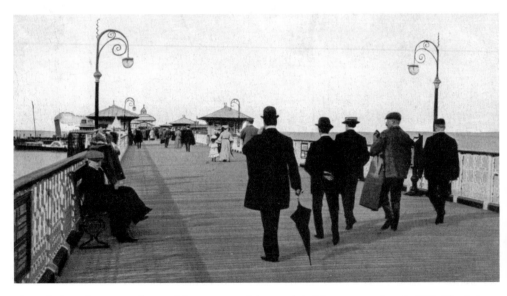

The walk along the pier is still part of the attraction of the seaside holiday, as it was here in 1910. The designer and engineer for the pier was Brunlees, who had already designed the piers at Rhyl and Southport. The contractor was John Dixon. Much use is made of ornamental ironwork in the railings, lamp posts and brackets.

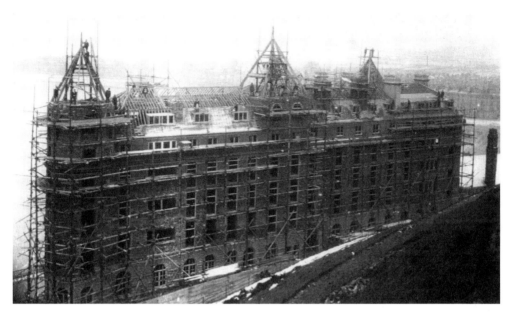

The Grand Hotel was built in 1901, where the Baths Reading Room and Billiard Hall had stood since 1855. The rubble from the Baths was used to fill up what had been Britain's largest indoor swimming pool underneath the Pier Pavilion. This very rare photograph shows the roofing of the Grand Hotel, which had 156 bedrooms and for many years was the largest hotel in Wales.

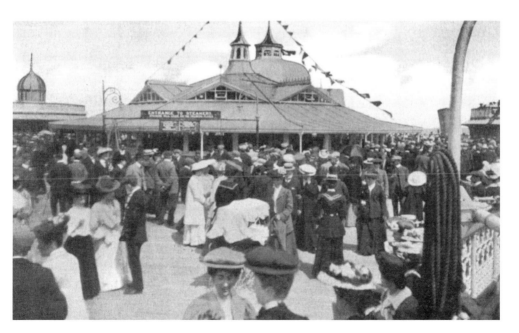

The pierhead buildings in this photograph replaced the simple octagonal structures that were on the pier originally. The people here are waiting for the return of the paddle steamer from its Anglesey trip so that they may return to Liverpool after their four hour stay in Llandudno.

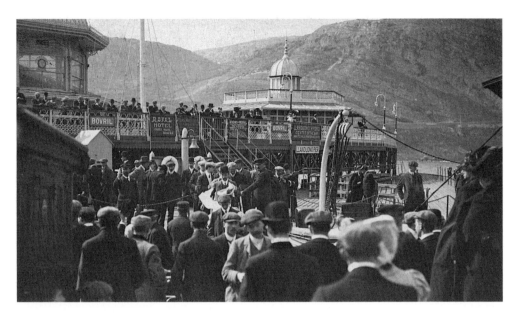

Passengers are embarking on the paddle steamer *La Marguerite* in this postcard view of 1910. For many years Llandudno Pier was a popular call for pleasure steamers because passengers were able to land and embark at any state of the tide.

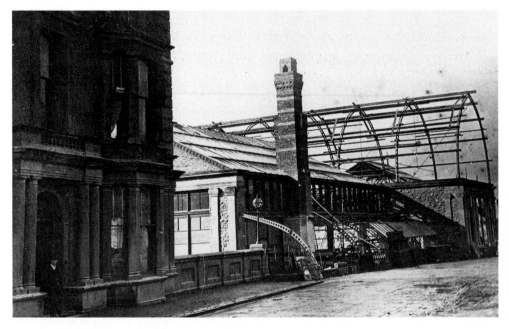

In the early years of the town's history the need for entertainment centres became apparent, and various halls were built to accommodate this demand. In 1886 the Pier Pavilion was opened. The original building had a glass roof, but this was short lived as inclement weather brought it to a premature end. The struts for this roof can be seen in this very rare photograph of the Pavilion under construction.

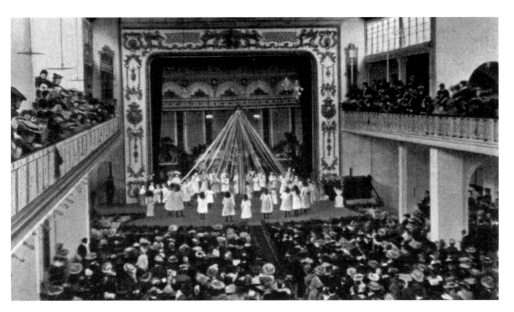

Normally, May Day celebrations took place in the Happy Valley, but if the weather was unsuitable the event moved into the Pier Pavilion. The maypole dancers here are the support act for the main event: the crowning of the May Queen. In 1913 a primitive cinema show was available for the visitors in the basement of the Pavilion. The show was advertised as 'The Royal American Bioscope'.

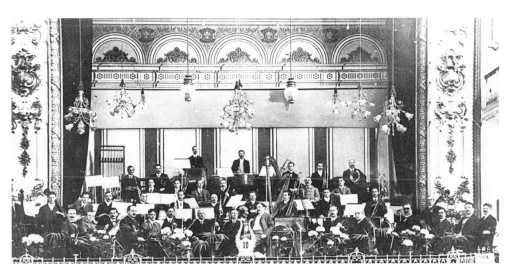

In 1887 Jules Rivière was engaged to conduct the seven-piece Tylor's Band at the end of the pier. He saw the opportunities offered by the newly built Pier Pavilion and after initial opposition he moved in. He increased the orchestra's size to twenty-eight and achieved a nationwide respectability. The great Sir Henry Wood, as a young man, was sent to study with Rivière and he described his experiences: Rivière conducted with his back to the orchestra seated on a golden armchair. His baton was encrusted with jewels and from it hung a large blue tassel. His flamboyant velvet jacket was embellished with a large orchid. This photograph shows the orchestra with Rivière seated behind the lyre-shaped podium. He left Llandudno and established an orchestra on Colwyn Bay Pier.

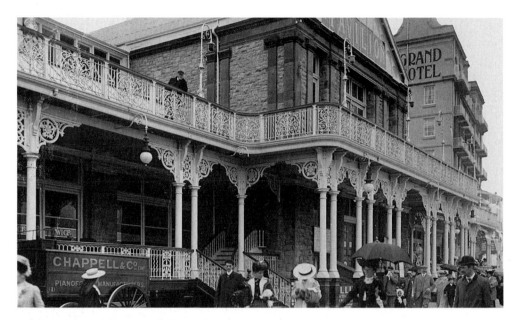

Many famous artistes have appeared in the Pier Pavilion. Sir Malcolm Sargent was the orchestra's conductor for two seasons (1926–28), and the young Paul Beard, one of the great orchestral leaders, started with the pier orchestra before being 'poached' by Sir Thomas Beecham for his London orchestra. Sir Adrian Boult was a guest conductor on several occasions. The beautiful voice of Adelina Patti singing *La Traviata* was heard here, and it was said to have reduced even the seagulls to tears of joy.

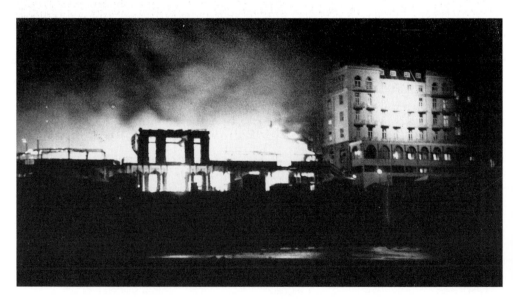

On a bitterly cold night in February 1994 the Pier Pavilion caught fire. This was the culmination of years of disgraceful neglect; the building was unused and slowly disintegrating under the battering of the weather. Fire services from all over North Wales could not save the beautiful building, but were able to stop the fire from spreading to the Grand Hotel and other hotels in the vicinity.

SECTION THREE

THE BEACH

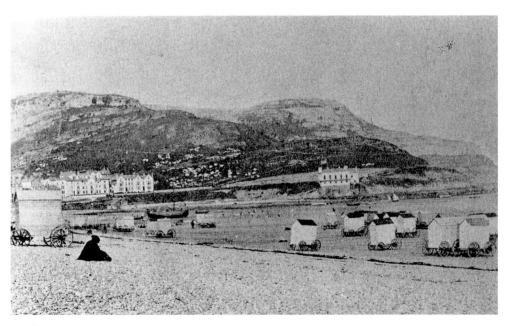

This is a very early beach scene, c. 1860. Bathing machines are evident even at this early date; they were introduced into Llandudno in 1855. There is no pier and the Bath House is without its tower. In the middle distance at the foot of the Orme there is a beached copper boat, (possibly) awaiting a cargo of ore.

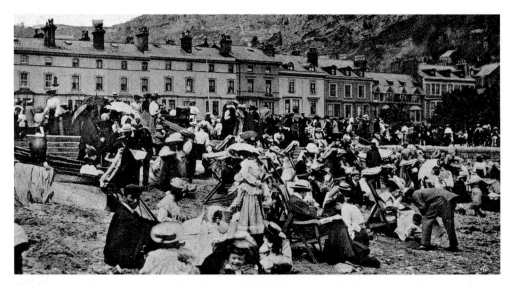

Beach scene, *c*. 1908. Sunburned skin was considered to be the prerogative of the labouring classes in Victorian and Edwardian Britain, hence the preponderance of parasols, sun hats and voluminous clothing in early beach scenes. In 1905 Llandudno Council voted not to allow the use of deckchairs on a Sunday. The *Manchester Guardian* accused the council of 'dealing a little unkindly with their visitors in depriving them of a quiet snooze in a beach chair on Sunday afternoons'. A local press comment said: 'Llandudno is in danger of being regarded as the home of narrow-minded puritanism – the bad sort of Puritanism instead of the good.'

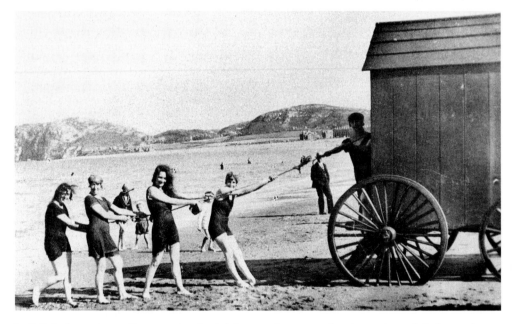

In 1868 the Improvement Commissioners decided that enough was enough with regard to nude bathing in the seas at Llandudno, and a by-law was passed to stop it. Bathers had to use a bathing machine, which was horse drawn into the water until it was deep enough to prevent indecent exposure. The cost was 6*d* for a forty minute bathe.

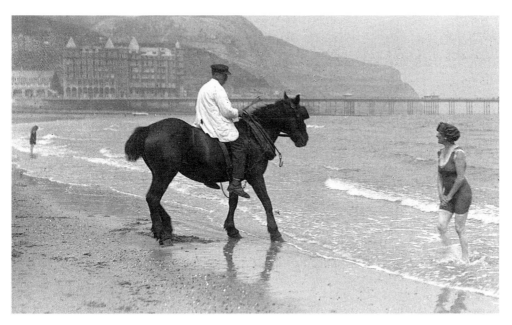

Samuel Edwards (1862–1926), a bathing machine proprietor, *c.* 1910. He was an extraordinary man. During the course of his life he saved thirty people from drowning. In one incident a seaplane came to grief in the bay and Samuel Edwards' horse hauled it ashore amidst the applause of a crowd which had assembled. His brother, Robert Edwards, saved twenty lives and his son William Edwards (also a bathing machine owner) saved thirty-five lives.

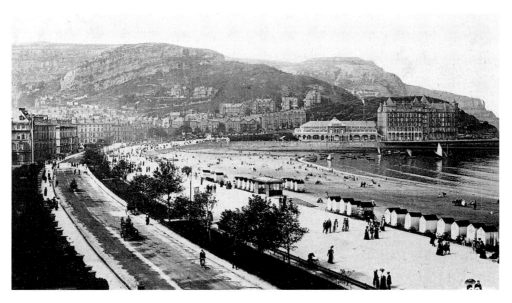

This photographic postcard was posted in 1912 and shows the large number of bathing machines on the beach, which provided a livelihood for several of Llandudno's families. They were still in use in 1958. Arnold Bennett's novel *The Card* was filmed in Llandudno in 1951 and the bathing machines were a feature of the film.

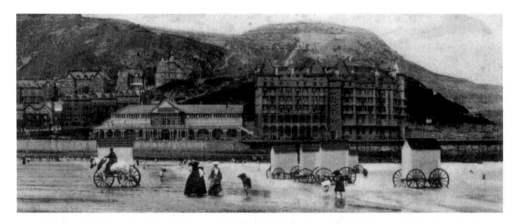

This photograph shows the segregated ladies' bathing area; it stretched from St George's Crescent to Clonmel Street, while the beach 150 yd from Clonmel Street was reserved for gentlemen. The gap was increased to 200 yd in 1868. A by-law passed then stated: 'Any gentleman who shall bathe within 200 yards of the Ladies' Bathing Ground, or any lady who shall bathe within 200 yards of the Gentlemens' Bathing ground shall forfeit a sum not exceeding 40 shillings.' In 1894 the Commissioners decided to allow mixed family bathing in one part of the beach opposite the Arcadia Theatre.

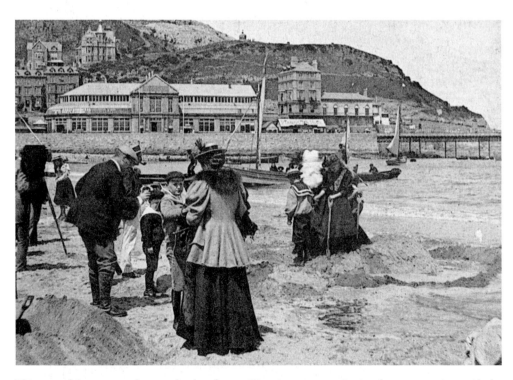

This turn-of-the-century photograph taken from a Victorian stereoscopic view bears comparison with the first photograph in this sequence (p. 41). In the background there have been noticeable changes: there is now a pier, the Bath House has its tower, and the Pier Pavilion has been built. Lot Williams has also built his camera obscura on Camera Hill.

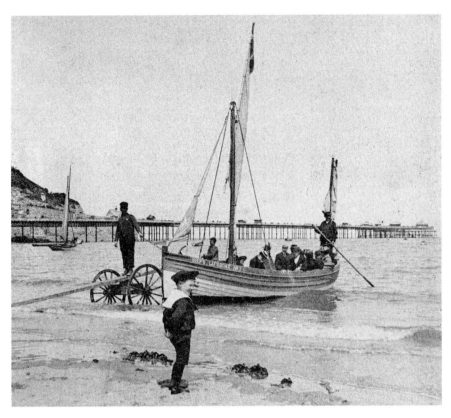

Another photograph taken from a stereoscopic view; the absence of the Grand Hotel dates this as pre-1901. It is interesting that the boat is called *Ship's Lifeboat No. 1*. Possibly it is salvage picked up after one of the many wrecks that occurred around the Orme and Llandudno Bay at this time.

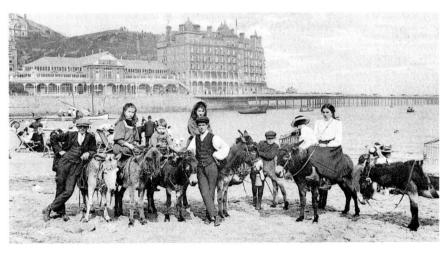

Members of the Hughes family who started the traditional donkey treat in Llandudno are seen here, *c.* 1910. For over a century this family has been associated with the donkey rides on the beach.

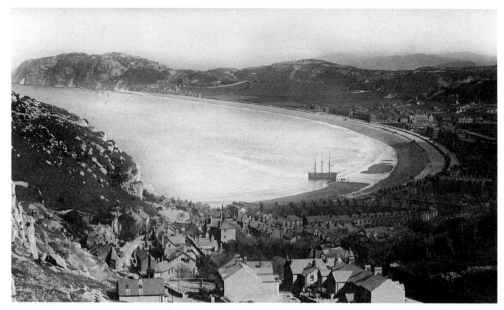

A beached schooner in the bay, 1911. In the early nineteenth century schooners would appear regularly and beach themselves at low tide. They would unload the incoming cargo and load up with copper ore which would be shipped out for smelting.

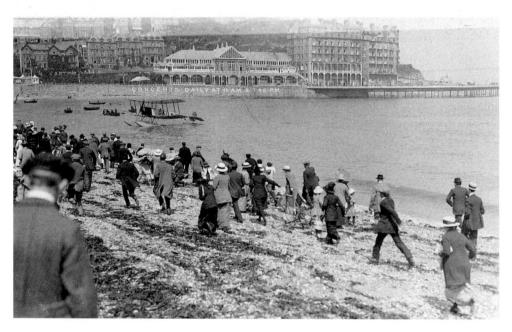

Excited crowds hurrying to see a very novel phenomenon for the time, June 1914. The *Daily Mail* sea plane has just landed and is approaching the shore. For the price of 4 gns the plane offered short flights with lovely scenic views. For the average working man at this time 4 gns was probably the equivalent of a month's wages.

SECTION FOUR

THE PROMENADE

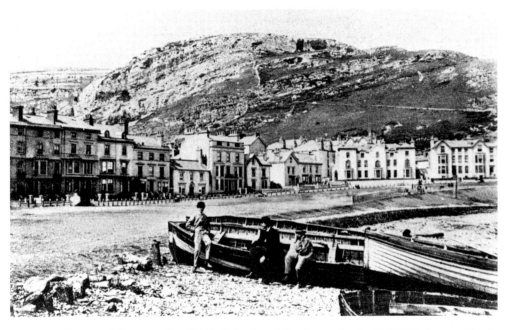

This is the oldest part of the Promenade, called North Parade, and this photograph is dated 1875. The houses and hotels shown here began to appear in 1855 as the Promenade developed to meet St George's Hotel, which was built in 1854. The best-known hotel in North Parade is the St Tudno Hotel. It was built by a Dwygyfylchi man named Thomas Jones. Dean Liddell and his entourage stayed there for Easter 1861.

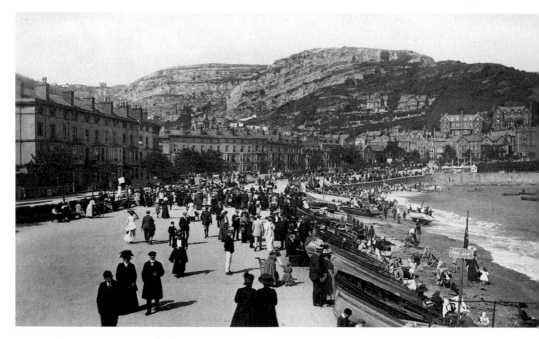

The Promenade, photographed here in about 1910, extends the whole length of the bay and is 90 ft wide and about a mile and a half long. There are seats the length of the Promenade and shelter, should the weather be inclement. The sweep of the Promenade as viewed from the Little Orme approach to the town is one of the most beautiful townscapes in Great Britain.

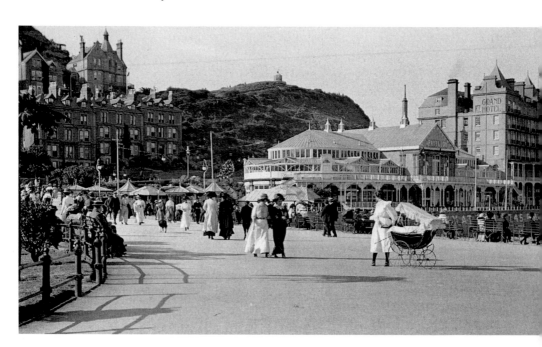

A lovely photograph of the Promenade on a Judge's postcard dated 1912.

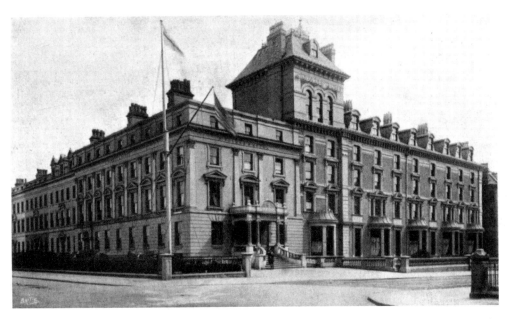

St George's Hotel was built in 1854 and was the first major hotel on the Promenade. Isaiah Davies was the first proprietor, and his family ran the hotel for over one hundred years. Many famous people have stayed here including four prime ministers: Disraeli, Gladstone, Lloyd George and Winston Churchill. Napoleon III and the Empress Eugenie, and Bismarck also enjoyed its hospitality.

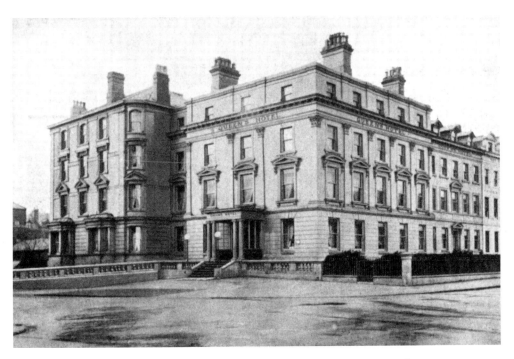

The Queen's Hotel was built in 1855, soon after St George's Hotel, and was very popular.

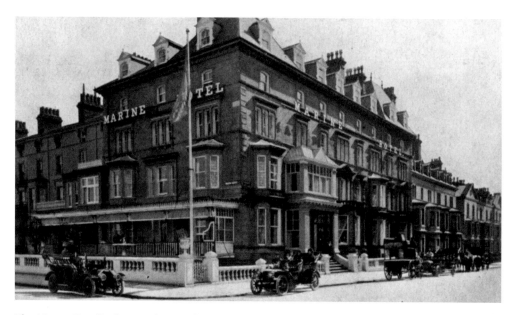

The Marine Hotel's claim to fame is that it was the home of a queen for five weeks in 1890. She was Queen Elizabeth of Roumania, who was also a writer with the pen name Carmen Silva. Her stay has left a permanent mark on the town. She said of Wales that it is a 'beautiful haven of peace', and these words translated into Welsh ('Hardd, Hafan, Hedd') are now the town's motto. In the Craig-y-Don area there is a Carmen Silva Road, and a Roumania Drive.

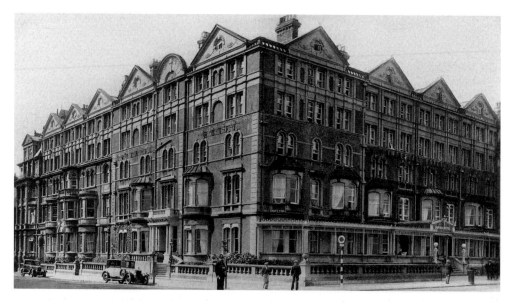

This is the Imperial Hotel, which was the headquarters of Great Britain's evacuated Inland Revenue Department during the Second World War. The hotel came into being in 1872 by amalgamating a row of smaller boarding houses built in 1865. It too was host to a queen, the exiled Queen Rambai Barni of Siam – who had to find alternative accommodation when the Inland Revenue arrived.

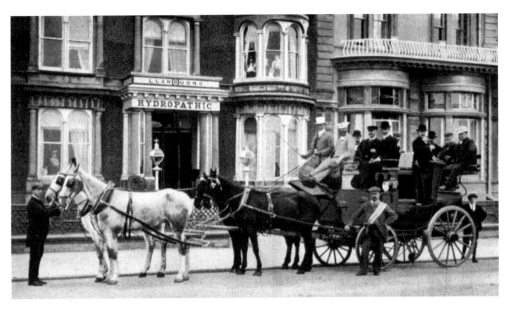

The Hydro Hotel, here called more correctly 'The Hydropathic', was opened in 1860 by an enterprising Dr Norton who wished to capitalize on the vogue for taking the water and sea bathing as curative measures. It was taken over by a man named Dr Henry Thomas of Caernarfon, whose qualifications were questionable (MD Homeopathic College of Pennsylvania). The 1858 Register of Medical Practitioners refused to recognize his qualifications, but he carried on regardless, offering a wide range of treatment.

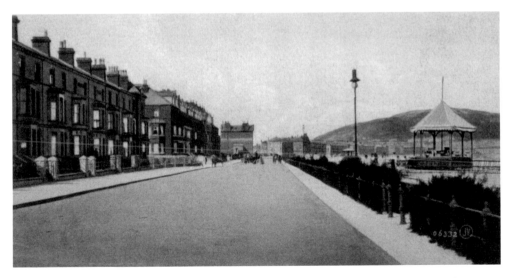

This view down the Promenade from the Craig-y-Don area shows the original Washington Hotel, c. 1910. The building actually protruded 50 ft on to the Promenade, and as road traffic began to increase it proved to be a hazard. It was demolished in 1925 and the present Washington was built in the same year. The pointed structure on the right of this photograph is the bandstand, known as the 'Juggernaut'. It had wheels and was trundled noisily along the Promenade pulled by horses. The band could therefore play where it was required.

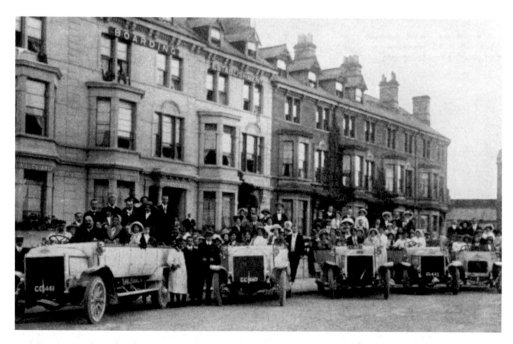

The Craig-y-Don area developed later than the main Llandudno part of the Promenade, and the Ormescliffe is of that later development. A fleet of five charabancs is ready to take a party of guests on a tour. Discomfort would have been the norm in this type of travel: the wheels on the coaches are of solid rubber, and with the top down the unsophisticated road surfaces would have provided a bumpy and dusty ride.

The Royal Red Company has provided the coaches for this tour, which is leaving the Craig-y-Don Boarding Establishment. The hotel is now called the County Hotel and was for many years owned by the snooker champion Fred Davies. Fred's brother, Joe Davies, was a world champion, and all-time great in the snooker world and their exhibition matches attracted large crowds.

SECTION FIVE

STREETS & BUILDINGS

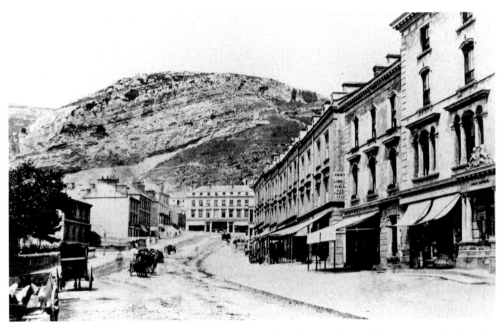

An early photograph of Upper Mostyn Street, c. 1880. The building facing at the top of the street is now the Empire Hotel, but at this time was Llandudno's first supermarket, the Italian Warehouse. It was built and owned by a Denbighshire man, Thomas Williams. He published a Complete Guide to Llandudno, *which is a mine of information for the local historian. His business was established in 1854.*

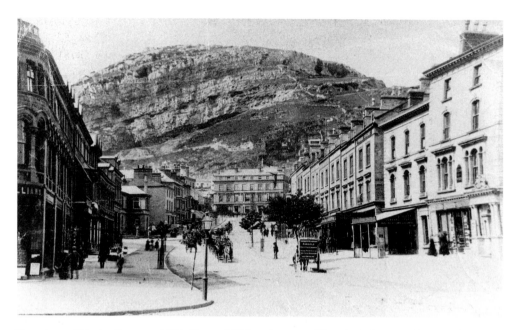

Two views of Mostyn Street, c. 1890. Thomas Williams has moved from his Italian Warehouse and is now at the corner on the left of these photographs. His guidebook advertises the move, and contains a sixteen page inventory of what he offered for sale, ranging from orange quinine wine to fine toned Chinese gongs. He later merged with T. Esmor Hooson, and the corner became known as Hooson's Corner. The building on the opposite side of the road is Llandudno's post office; it moved there from 19 Old Road, which was the first post office in Llandudno.

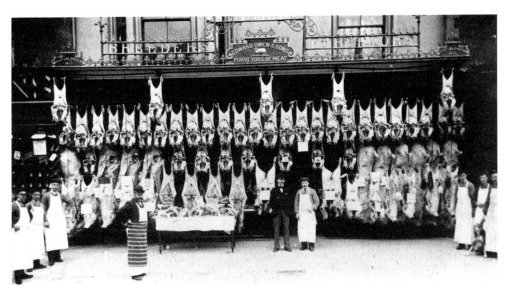

A sight to chill the heart of any vegetarian or food hygienist – Edward Owens' butcher's shop in Mostyn Street. Edward Owens is standing apron-less and bowler-hatted in the shop doorway. The sign asserts that the business was founded in 1834, but this was several years before there were any buildings of this sort on Mostyn Street. It is believed that he started his business in the fishermen's hut on the shore mentioned earlier in this book (see p. 8). The shop sign is there today.

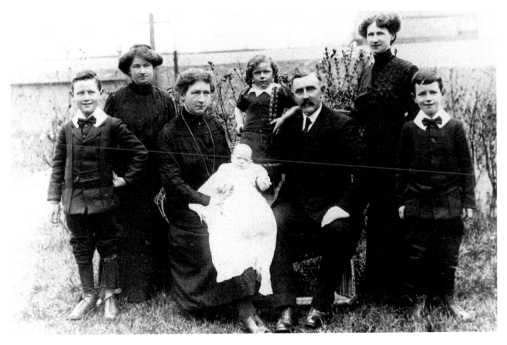

Edward Owens, butcher, poses with his family for a typical Victorian family portrait. The six children bear a striking resemblance to their mother.

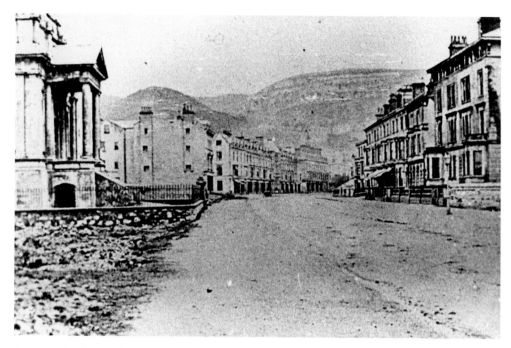

A very early photograph of Mostyn Street, *c.* 1865. At this time the street was undergoing a phase of intensive building, its unmetalled surface constantly being torn up to connect dwellings to water, gas and sewage amenities. Though not easy to traverse in wet weather, the real discomfort came from the sea breezes and the dusty road surface; this became a particular and universal problem much later when motor cars sped through the streets. Llandudno is alleged to have been one of the first localities in the country to experiment with tar for the laying of dust and road levelling. Other authorities turned to frequent watering of the road surfaces to solve the problem. The building on the left with an imposing portico and stepped access is the Zion English Baptist Chapel, built in 1862. This was demolished in 1967 when Mostyn Estates refused to extend its lease. For many years the only reminder of the chapel was the tree which was planted 120 years ago (1877) in memory of the first wedding to be blessed in the chapel. Sadly the tree has been cut down this year (1997), a victim of Dutch Elm Disease.

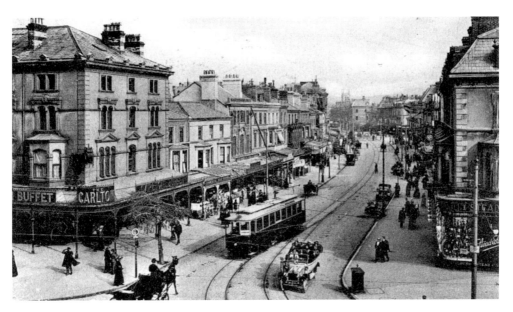

This is the corner of Mostyn Street and Gloddaeth Street in a photograph taken just before or during the First World War (the postcard is dated 1917). The sender of the card informs its recipient: 'My dear boy has had a marvellous escape, and is now a prisoner of war in German hands.' A poignant social comment.

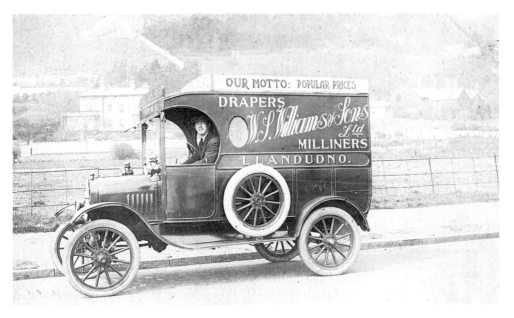

W.S. Williams' van, *c.* 1918. The shop was situated in Mostyn Street and was known as 'Arthurs, The Pioneer'. In 1927 it was bought by Robert Clare Baxter who changed the name to Clare's Modern Store. Clare's is one of the few privately owned shops remaining in Mostyn Street. W.S. Williams also started Marie et Cie, the quality ladies' outfitters in Gloddaeth Street. The French name was used because many of its fashion products were bought in France. The shop is now called Mackays.

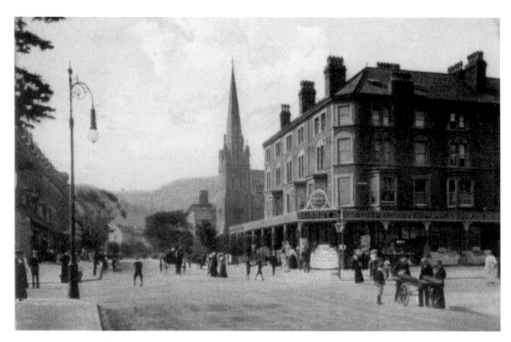

Bunney's Shop stood on the corner of Mostyn Street and Clonmel Street for many years. It was owned by a family who had a similar shop in Liverpool. The building was demolished at the end of 1987 and rebuilt as Greenwoods.

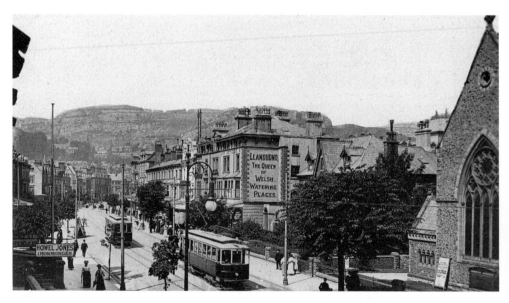

Two trams on a passing loop outside the Domestic Bazaar Company in Mostyn Street, 1909. All the goods in the shop are on offer at 6 ½d each, an adoption of the early Woolworths trading technique. The building in its own gardens to the left of St John's Methodist Church was bought by Marks and Spencer, who now occupy the site.

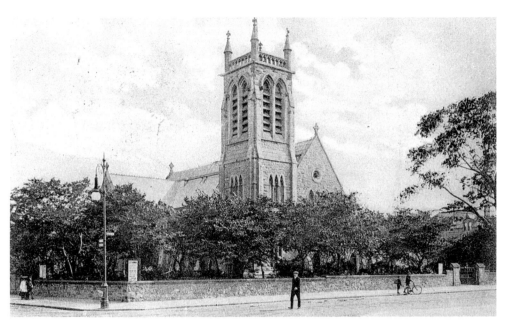

This church, situated in lawned grounds in Mostyn Street, was opened in 1874 after some ten years under construction. The foundation stone was laid in 1865 by the rector's wife Mrs Kathleen Anwyl Morgan. It was built in response to the needs of a rapidly expanding town with a large influx of visitors each year. The church tower with an eight bell peal was not added until 1892, and other building work was completed in 1924 and the early 1930s.

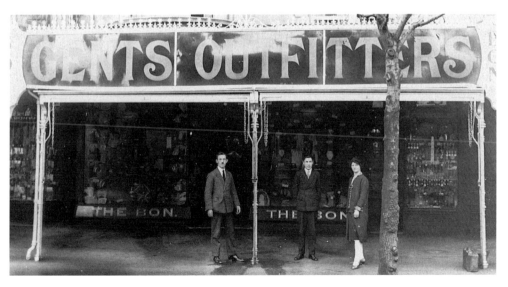

This is the Bon Gents Outfitters, c. 1918. The shop was purchased in 1925 by Robert Clare Baxter who had seven shops in North Wales, collectively known as Baxter's Dependable Drapers. He changed the name to Baxter's Bon, and the shop (which specializes in high quality clothing for men and women) is still owned and run by Mrs Gwyneth Smith, the daughter of Robert Clare Baxter.

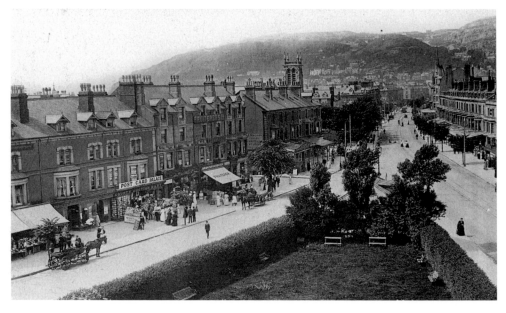

Mostyn Street from the first floor of the St Tudno Castle Hotel, 1910. The familiar triangle of North Western Gardens is in front of the hotel. The gardens were once owned by the hotel but are now the property of the town council. In the 1920s public toilets were built underneath the gardens.

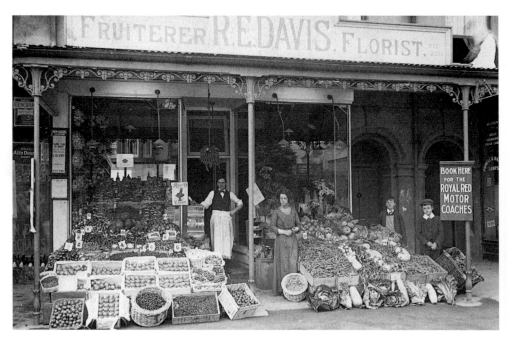

R.E. Davis, fruiterer and florist, in Mostyn Street bordering North Western Gardens, *c.* 1918. Delivery boys and bicycles were a familiar part of shopping in the first half of the century, and two of the boys are posing in the photograph with Mr and Mrs Davis.

The North Western Hotel, *c.* 1925. This was named after the London and North Western Railway Company. Originally it was two hotels, the Tudno Castle nearest the shore and the Temperance Hotel bordering Conway Road. This was the view up the Conway Road; the only building in view is the Links Hotel, standing in splendid isolation in an area which is now built up.

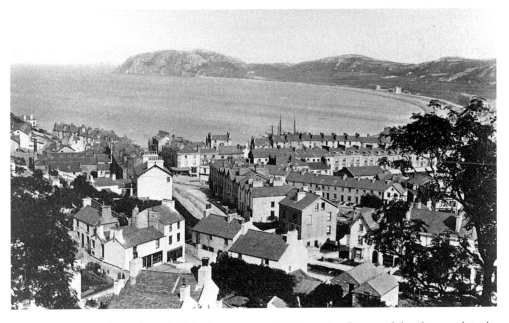

An early town view from the end of the last century. The interesting feature of the photograph is the presence of a ship on the shore, the masts and rigging of which can be seen above the rooftops of the promenade hotels.

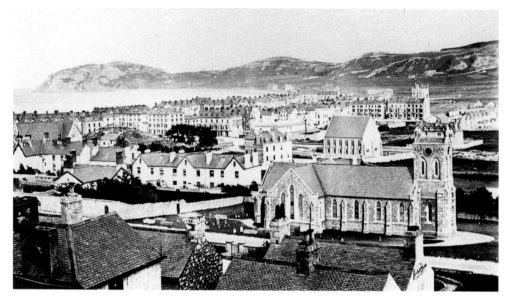

This is a very early view from the side of the Great Orme with Church Walks in the foreground. The town is in a relatively undeveloped state, which suggests a date of about 1875. The church in the right foreground is St George's Church, the Anglican parish church, built in 1840. It was built as a replacement for St Tudno's Church, which at this time fell into a very bad state of disrepair. St George's was designated the parish church in 1862.

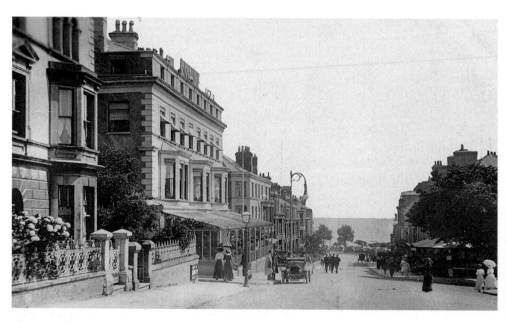

Church Walks is one of the oldest streets in the town. The street gets its name from St George's Church. In the early history of the town the street was its administrative hub. It was the location for many of the town's 'firsts', for example, first bank, town hall, post office, police station, gaol, court, water and gas board offices and supermarket.

Church Walks, and two interesting hotels. The Royal Hotel on the right was originally the Mostyn Arms and was the first major hotel in the town. Bodlondeb Castle, the castellated building to the left of the road, is known locally as Davies' Folly. It was originally intended as a private house, and it is said that Davies never actually lived there. In its lifetime it has been a school, a First World War military hospital, and a Methodist holiday home.

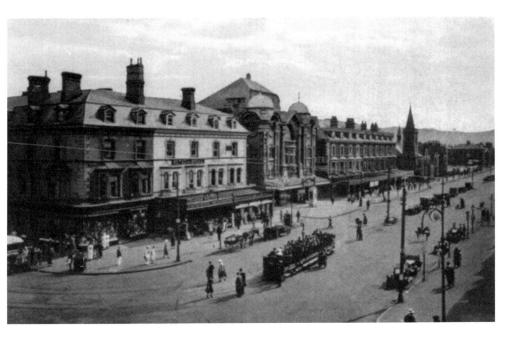

Gloddaeth Street, c. 1925. The Creuddyn Isthmus is bisected by Gloddaeth Street and Gloddaeth Avenue, a thoroughfare which is ¼ mile long. This photograph shows the Palladium cinema, built in 1920 on the site of the original Market Hall. The Palladium could hold 1,500 patrons and is now the only cinema left in town.

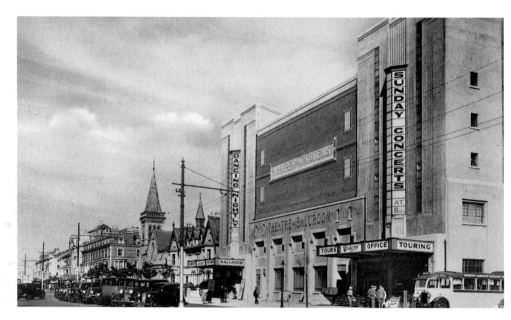

The Astra Theatre and Winter Gardens, Gloddaeth Street, was built in 1934 on what had been a market garden. This was the only theatre in North Wales large enough to accommodate full-scale operatic productions, and it became the North Wales home of the internationally famous Welsh National Opera. The theatre held approximately 1,700 people and attracted other companies of international repute: the Carla Rosa Company, the D'Oyly Carte Opera Company, the Sadlers Wells Ballet and so on. The site is now occupied by residential flats.

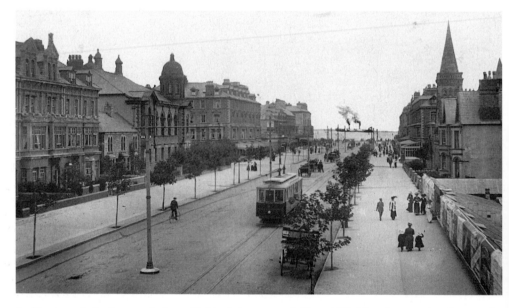

Looking towards the Promenade down Gloddaeth Avenue, probably *c.* 1908. The advertising hoardings on the right border the market gardens known as The Vineyard on which the Astra Theatre and Winter Gardens were built in 1934. In the background, on the bay, *La Marguerite* is steaming away from the pierhead on her way to Liverpool.

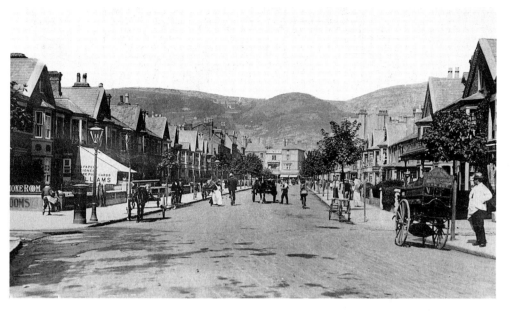

Madoc Street, c. 1910. This street was built parallel to Mostyn Street in 1870. Following the Enclosure Act (1843), and the auctioning of the land to leaseholders, several of the original Llandudno inhabitants were living 'inconveniently' on the prime sites in the town, for example, on the Promenade and Mostyn Street. Consequently they had to be moved. Mostyn Estates evicted these tenants and housed them in Madoc Street.

Chapel Street, c. 1912. On the corner of Chapel Street and Gloddaeth Street is the English Presbyterian Chapel, built in 1891, from which the street gets its name.

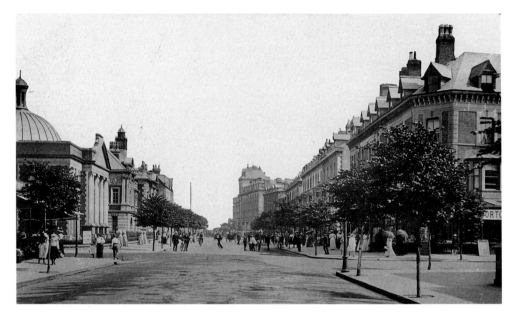

This photographic postcard of 1908 shows that little has changed in Lloyd Street over the years. The street, which opened in 1866, was to have run from shore to shore, but it terminated in the popular sporting venue, the Oval, where football and cricket have been played since 1890. The domed building on the left is the Ebenezer Welsh Methodist Chapel, which was opened in 1909 on the site of the former Ebenezer Chapel, opened in 1874. The present building was designed by W. Beddoe Rees. It is now a Christian Community Centre.

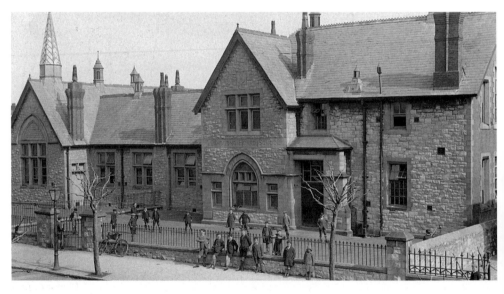

Lloyd Street School, *c.* 1920. This was the town's first Board School, and was established in 1881. The memorial stone was laid by the town's MP, W. Rathbone. The chairman of the board was Benjamin Woodcock, the proprietor of St George's Hall. Another foundation stone was laid by John Bright MP, the famous liberal dissenter. In the 1980s the school was closed and the children transferred to Trinity Avenue.

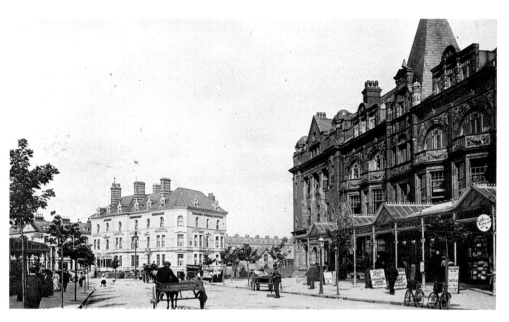

This terrace of shops and boarding houses is Vaughan Street. It was designed by G.A. Humphries, a Mostyn Estates agent, and built in 1844 when it was known as Bay Street. The building at the end of the terrace is the post office, built in 1904 on part of the site of the 1896 National Eisteddfod which had a 10,000 seat pavilion. The post office was opened by Lord Stanley, the Postmaster General, in May 1904.

The railway station is at the junction of Vaughan Street and Augusta Street. A horse omnibus is awaiting the arrival of one of the frequent trains from Llandudno Junction.

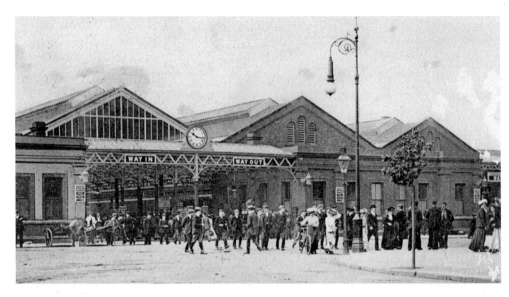

Passengers leave Llandudno station, *c*. 1905. Before the link was built between Llandudno and Llandudno Junction, train passengers had to travel to Conway and were then transported by horse and carriage to Llandudno. Vaughan Street had to be extended in 1858 to reach the first railway station, and as a result a prehistoric site was desecrated when a long barrow was cleared away. The present station was built in 1891.

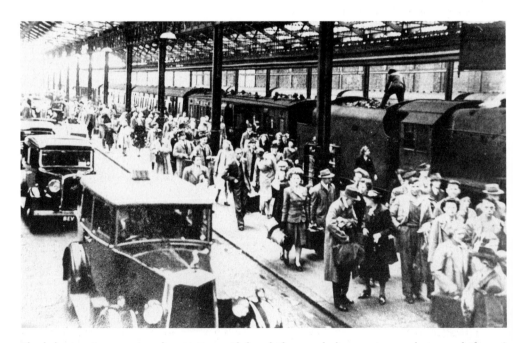

Llandudno terminus was a very busy station, with five platforms and a long carriageway between platforms 2 and 3. Trains arrived every four minutes during busy holiday times, and disgorged thousands of day trippers. In the 1940s, despite the rising popularity of the motor car, 212,000 people arrived in Llandudno by train, an average of 40,000 per week.

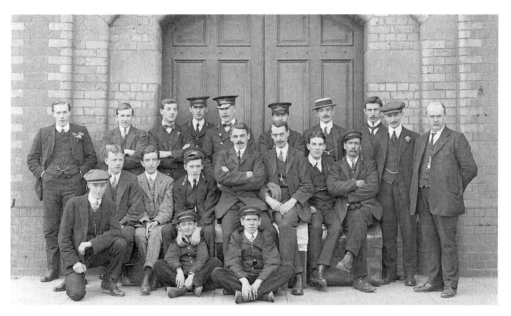

Llandudno railway station staff pose outside the station. There are twenty people in this photograph ranging from the stationmaster, who is in the middle of the back row, to the young lad who sweeps the platform sitting on the ground. Now there are four full-time staff at the station, an indication of the diminishing role of the railway in competition with road transport.

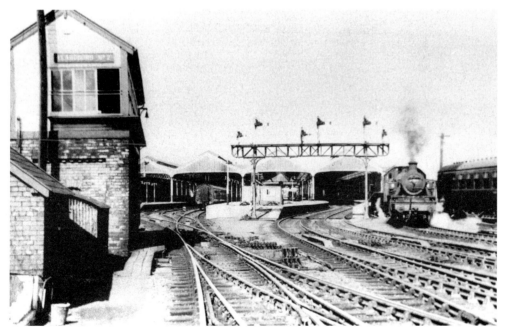

An excursion train leaves the station with returning holiday-makers, c. 1940. The platform canopies seen here were removed in the 1980s because of high maintenance costs.

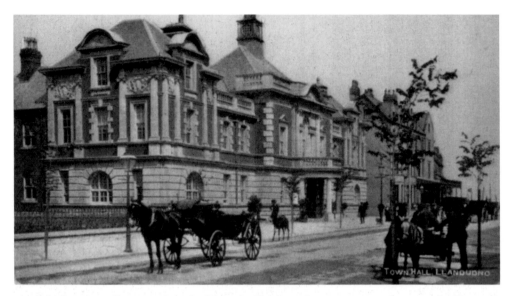

Llandudno's Town Hall is situated in Lloyd Street and has been there since 1902. The present building took eight years in planning and construction. The design was a prizewinning one, and in 1894 the winner, T.B. Silcock, was presented with £50. The builder was a local contractor, Mr R. Luther Roberts, and during the course of building there was a great deal of controversy. The cost rose from an estimated £10,000 to the sum of £20,000. The first meeting held in the premises was an acrimonious enquiry by the Government into the reasons for the increased costs.

This small cottage hospital, the Sarah Nicol Memorial Hospital, was opened in May 1885 in Trinity Avenue, to commemorate Mrs Nicol who died in 1884. There was provision for some forty beds, but as the town developed they became insufficient and Llandudno General Hospital took its place in 1939. The building is now a Youth Centre.

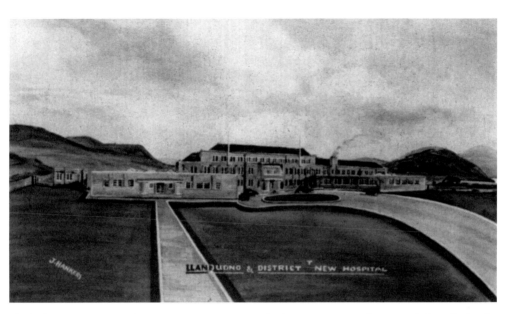

Llandudno General Hospital, pictured here in 1940, was built in 1939. Originally it provided 130 beds. The increase of some ninety beds was necessary as the town developed, particularly as there was a large increase of workers in the town evacuated here because of the war. It was opened by HRH Princess Alice on 12 August 1939. Princess Alexandra visited it in 1960, and the Duchess of Kent in 1950.

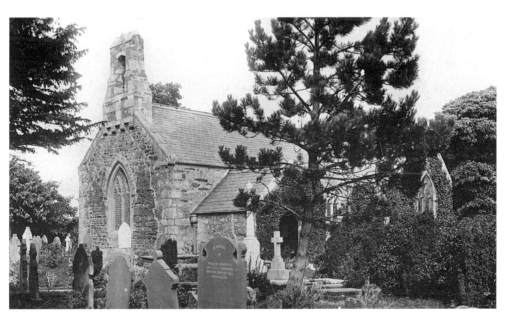

Llanrhos Church, 1908. The ancient church has been much renovated, including a rebuilding in 1865, but a great deal of its early medieval structure still survives. It is the burial place of members of the Mostyn family. The building is traditionally associated with the death of the Welsh Prince, Maelgwyn Gwynedd, from a yellow plague that raged in Britain and Europe in the middle of the sixth century.

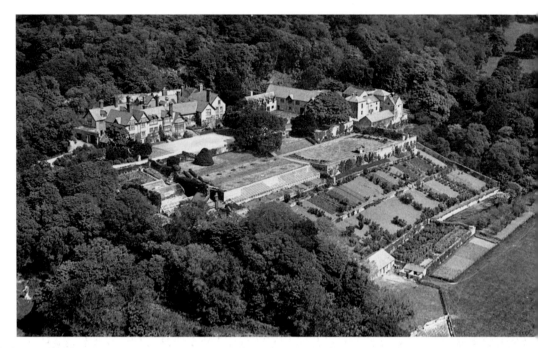

This aerial view of Gloddaeth Hall shows the house situated in its magnificent grounds, *c.* 1950. For centuries the house was the home of the Mostyn family, having come into its possession through marriage in 1460.

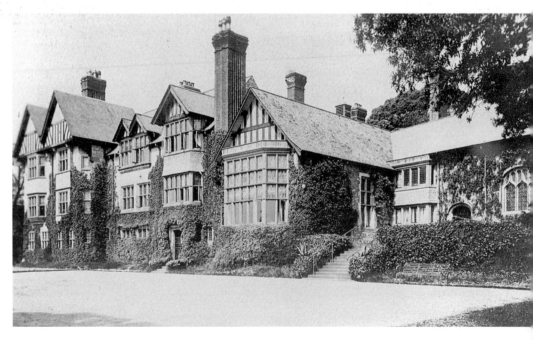

The building has undergone considerable modification through the centuries, and the oldest part is the Great Hall, which dates from the sixteenth century. The hall is now the home of St David's College, a large private school.

SECTION SIX

THE WEST SHORE

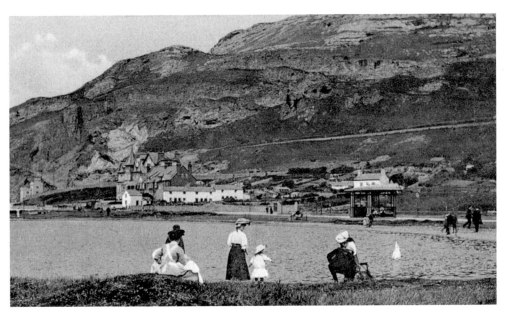

This view from a postcard posted in 1919 shows the West Shore. In the background, from left to right, we see the toll house at the end of the Marine Drive, Gogarth Abbey Hotel, and in front of it a row of white cottages built in 1783 to house copper miners. (see pp. 13 and 14). The line running across the photograph above the buildings is Invalids' Walk, a gently sloping path which leads to Haulfre Gardens and The Happy Valley.

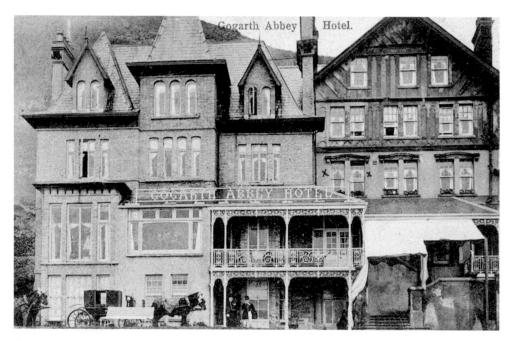

This photograph, dated 1913, shows the building which is now famous because of its association with Alice of *Alice in Wonderland* fame. Alice is said to have been inspired by Alice Liddell, who was the daughter of the Very Revd Henry Liddell, the Dean of Christchurch, Oxford. During a visit in 1861 he fell in love with the West Shore and had a house built there in 1862. This house, called Pen Morfa, is the four-storey structure to the left of the photograph.

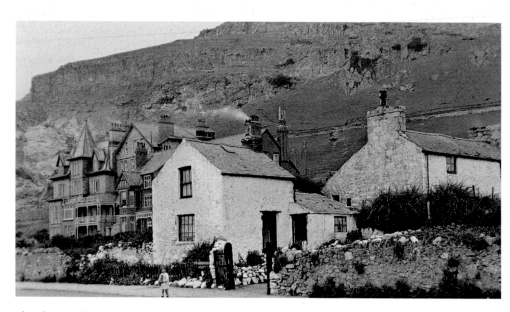

This photograph was probably taken in the 1920s. It is a closer view of the Gogarth Abbey Hotel and the Pen Morfa miners' cottages. The cottages were demolished in 1936.

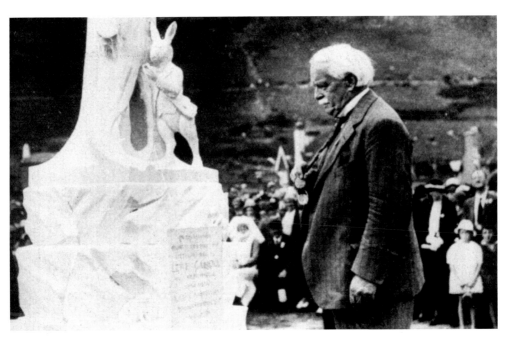

This photograph shows the Right Honourable David Lloyd George MP unveiling the memorial statue which affirms the traditional belief in the link between the 'Alice' books and Llandudno, 1933. The inscription reads: 'On this very shore during happy rambles with little Alice Liddell, Lewis Carroll was inspired to write that Literary Treasure "Alice in Wonderland" which has charmed children for generations.' We are not sure that Lewis Carroll actually visited Llandudno. Alice was undoubtedly the inspiration for his stories, but was there a link with Llandudno? Lloyd George's words at the dedication of the memorial statue show that he firmly believed in the connection: 'The man we are commemorating was one of the really great men of the world. It was a holiday at Llandudno that did this. He breathed our invigorating air, he had the sea that stimulates thought, the mountains to elevate him, and a child to lead him.' Sir William Richmond, the portrait painter, painted the Liddell sisters using the Great Orme as a backdrop. He spent a considerable time in Llandudno, and states that they were entertained in the evenings by Dodgson (Lewis Carroll) reading aloud from the stories. Alice was eighty-four when the memorial was unveiled and, because of her frailty, was unable to attend. However, she sent a message saying: 'I still have the happiest memories of Pen Morfa . . . and of the rambles over the Great Orme's Head and among the Llandudno sand dunes. I wish I could come personally in gratitude for those joyous days, and for the days spent with Mr Dodgson.'

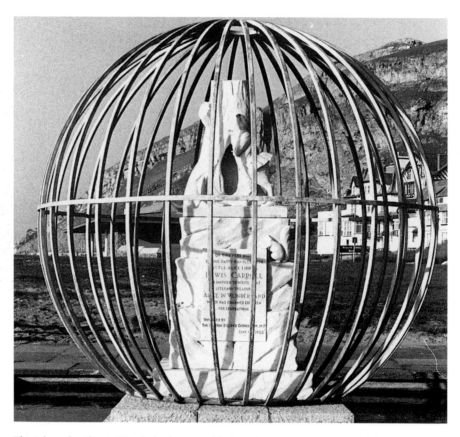

This is how the Alice in Wonderland memorial looks today. In recent years vandals have managed to inflict a great deal of damage to the statue. It is now encased in a stainless steel cage and surrounded by water. The rabbit's left ear is missing, and the left hand which held a pocket watch has also disappeared.

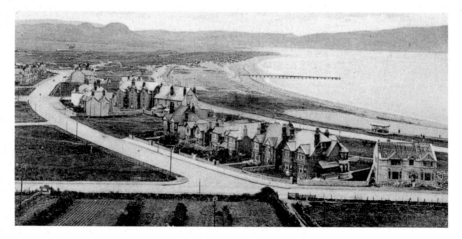

West Shore house building, *c.* 1920. Housing development in the West Shore area occurred much later than in the town and on the Promenade.

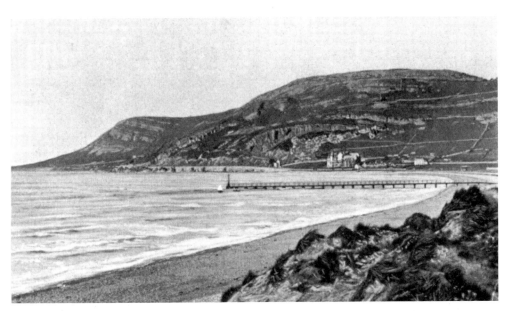

The jetty which jutted into the Bay from the West Shore, 1907. This jetty has now gone. On the shore in the background the only boat to be built in Llandudno was constructed and launched in 1863. Named the *Sarah Lloyd*, she was intended to be a copper boat, but the decline of copper mining in the mid-nineteenth century forced her to become a coastal tramp until she came to grief off Aberdaron in 1874.

This recent photograph shows the remains of the last schooner to be wrecked on Llandudno's West Shore. She was the *Flying Foam* of Bridgwater. On 21 June 1936 she anchored off Penmaenmawr to repair a sail. The weather worsened, and she dragged her anchor until she came to grief on the shore. She broached and had to be abandoned.

A walk along the beach for about half a mile brings the shore to the meeting place of the sea and the estuary of the River Conway. Here were the Black Rocks, a tumble of ancient boulders, the remains of a glacial moraine. Several of the rocks bore the scratches and striations typical of glacial origin. This photograph shows the Black Rocks as they were in 1986. In the background lies the *Sleeping Queen*, dozing gently with her nose in the air. An ugly, man-made groyne has now disfigured this part of the beach.

This is the North Wales Golf Club, which occupies the ground above the West Shore sand dunes. The club was established as a nine-hole course in 1893; it later became an eighteen-hole course. The North Wales Club is separated from Llandudno's other main golf course, the Maesdu Club, by the width of the railway line. In this picture the course appears to be in its nine-hole stage, as the present course covers the farmed area in the middle distance.

SECTION SEVEN

CRAIG-Y-DON

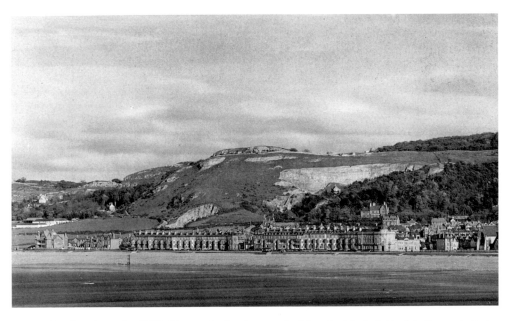

Craig-y-Don from the sea, late 1930s. This area developed as a result of the sale of the freeholds of the Beaumaris, Craig-y-Don Estates in June 1884. This made Craig-y-Don a more attractive place to own property than Llandudno, which had restrictions imposed by Mostyn Estates.

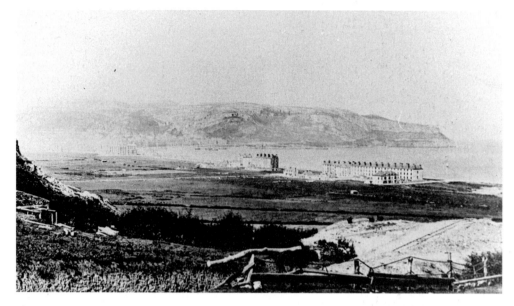

This is a very rare early view of Llandudno Bay from the quarry site in Craig-y-Don above Bodafon Fields. In the distance the Bath House nestles against an undeveloped Great Orme. The boats in the bay are too big to be pleasure boats, and are likely to be two-masted ore carriers. The photograph was certainly taken before 1894 because there is no sign of the Arcadia Theatre.

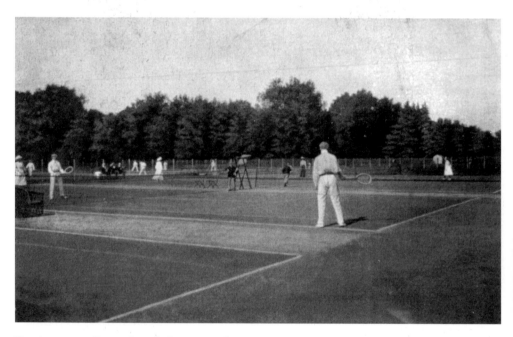

Tennis courts in Craig-y-Don, before 1905. The existing Queen's Road Courts were not built until 1931; this is possibly a photograph of Riddell and Jarvis' tennis courts which were situated on the land now occupied by St David's English Methodist Church.

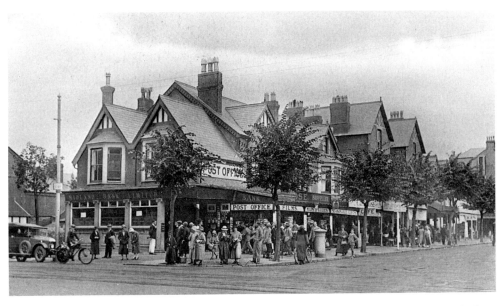

Queen's Road looking towards the Promenade from Dunphy's Corner, probably in about 1920. The busy post office and bank occupy a building that was once a dwelling house. Nowadays the post office is on the other side of the road.

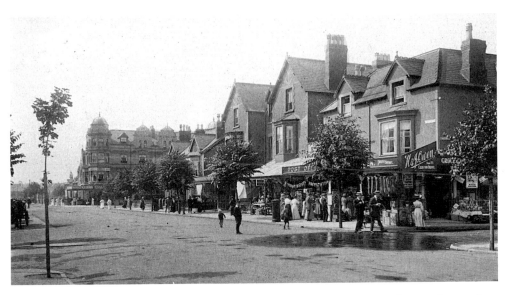

Queen's Road, Craig-y-Don, 1911. Many changes have occurred here since this photograph was taken. Dunphy's Corner, the building with the dome, was one of the high-class grocery stores belonging to an old-established Llandudno family, who founded their business in 1857.

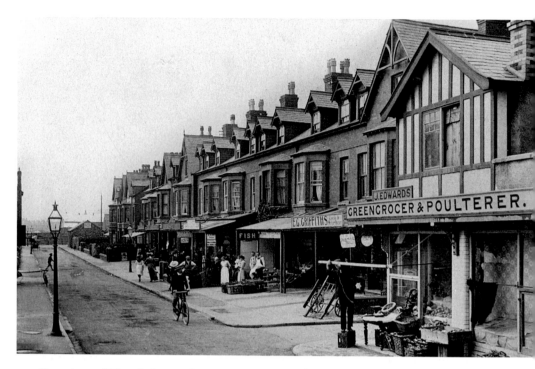

Two views of Victoria Street, Craig-y-Don, *c.* 1911. This street runs between, and is parallel to, the Promenade and Mostyn Avenue. The wealthier middle classes had their holidays in the hotels on the Promenade with the obligatory sea views. Streets such as Victoria Street provided an invaluable service for the less affluent, with boarding house accommodation.

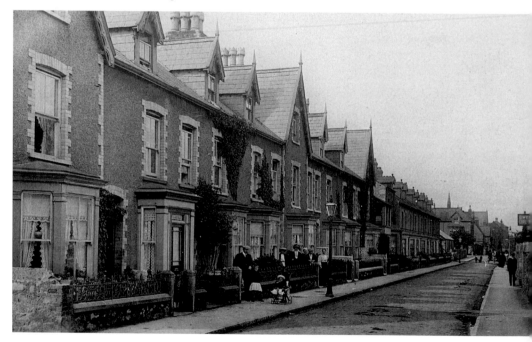

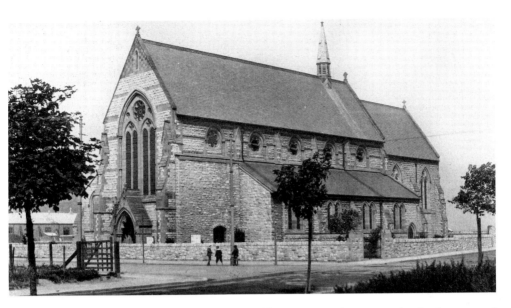

St Paul's Church, Craig-y-Don. Work started on this building in 1893, and it was completed and consecrated in 1901. It is dedicated to the Duke of Clarence who died aged twenty-eight in 1892. There is some circumstantial evidence, by no means conclusive, that the Duke could have been the notorious Jack the Ripper, whose activities so shocked the world in 1888. The church has been described as a memorial to this infamous figure.

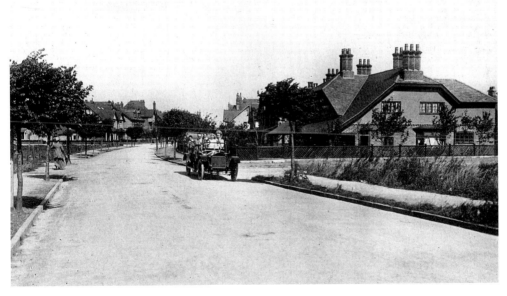

Carmen Sylva Road, Craig-y-Don, *c.* 1912. The road is named after Queen Elizabeth of Roumania, who stayed in the Marine Hotel in 1890. Carmen Sylva was her pen name. There is also a Roumania Drive and Sylva Gardens in the area.

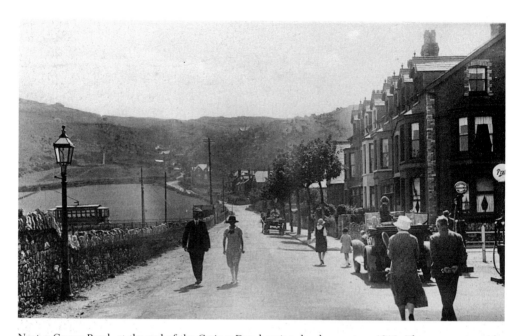

Nant-y-Gamar Road, at the end of the Craig-y-Don housing development, *c.* 1915. The name means 'the valley of the crooked furrow', and the road once led to a windmill. It crosses the tram track centrally in this photograph and a tram is approaching the crossing on its way into Llandudno. Bodafon Fields to the left of the photograph are ripe for desecration, and have been subjected to several abortive attempts by Mostyn Estates to put them to commercial use. In recent years there was an attempt by the estate to erect a Disney-style theme park based on the *Alice in Wonderland* connection. This was met with a storm of protest from local people anxious to preserve the beauty of this part of the bay. It was rejected at the planning stage because of the traffic problems such a venture would create. More recently, Mostyn Estates are proposing to construct further housing developments, leisure facilities and a large 'park and ride' complex with frequent trams into the town centre. This has also caused a great deal of local opposition and the controversy is ongoing.

The livery stables in Queen's Road, Craig-y-Don, late nineteenth century. Remnants of this building are still visible behind the garage façade that replaced it.

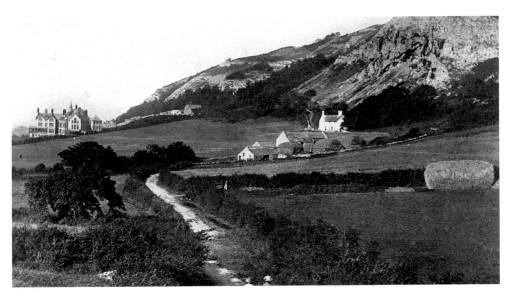

Fferm Bach (Little Farm) Walk, c. 1910. This lane leads to Gloddaeth Woods, and the hills above the cliffs, from which there are superb views. It was near here, in 1979, that two local treasure hunters found a hoard of over 200 King Canute silver pennies, the largest Viking hoard ever found in Wales. The find, now housed in the National Museum of Wales, was valued at £14,500.

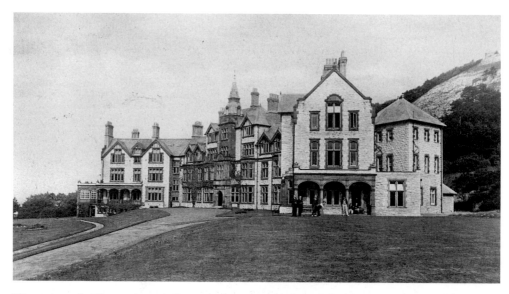

This imposing building was, until a few years ago, the Lady Forrester Convalescent Home. It was built in 1902 for the benefit of workers from the quarrying and iron-making industries of Shropshire. The home was built in memory of Lady Forrester's husband, the 3rd Baron Forrester, a general in the army, then an MP, and eventually Father of the House of Commons. He died in 1886. The building is now the North Wales Medical Centre, a private hospital.

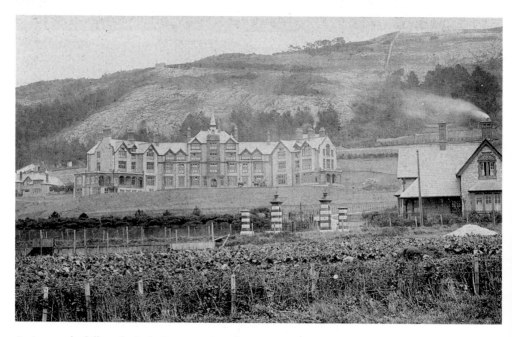

A view up the hill to the Lady Forrester Convalescent Home. This photograph was taken soon after the home was built. The view of the building is now obscured at this point by a line of very high conifers which are newly planted in this photograph.

LITTLE ORME
& PENRHYN BAY

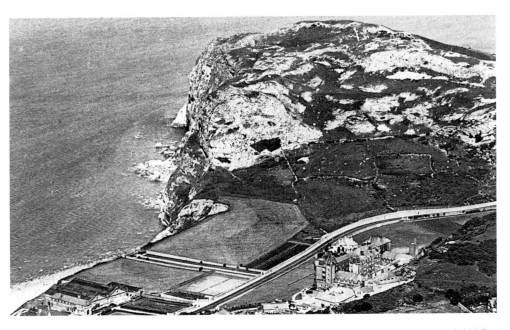

The Little Orme is 2 ½ miles away from her bigger sister across the bay. The headland is 463 ft above sea level, 200 ft lower than the Great Orme. Some of the cliffs have a sheer 300 ft drop to the sea and provide excellent climbing for the experienced climber. There are several caves formed by the sea and these can only be reached by boat.

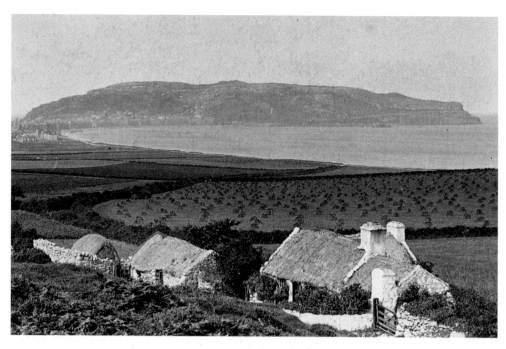

This view is from the Bodafon–Penrhyn Hill area overlooking the bay, before 1900. These were the last thatched cottages in the area. Craig-y-Don is little developed in this photograph.

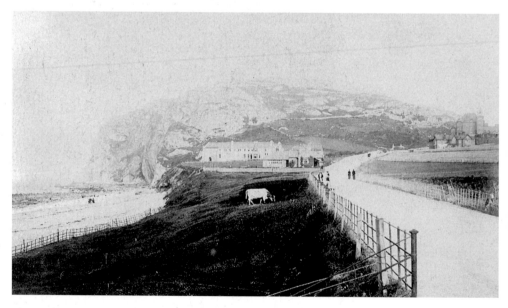

This card was posted in 1907, although the photograph could have been taken much earlier. It is a very rare view of this part of the bay. The buildings in the middle distance are part of the Craigside Hydro Hotel complex, the main buildings of which are on the other side of the road. There is now considerable housing development where these buildings stood.

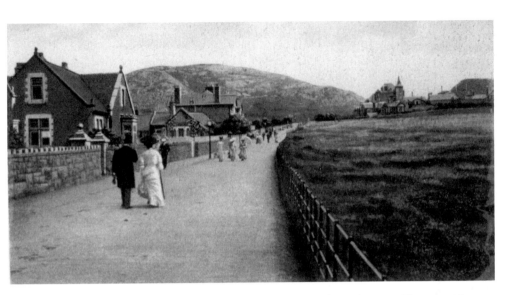

The road to Colwyn Bay over the Little Orme was once the main road into the town. There is evidence to suggest that this was the route taken by the Romans when they pursued their interest in the mineral wealth of the Great Orme. There have been two finds of Roman coins in the area, the first in 1873 when 5,000 coins were discovered in an earthenware jar; the second in 1907 when several hundred more were found at Craigside, and Mostyn Broadway.

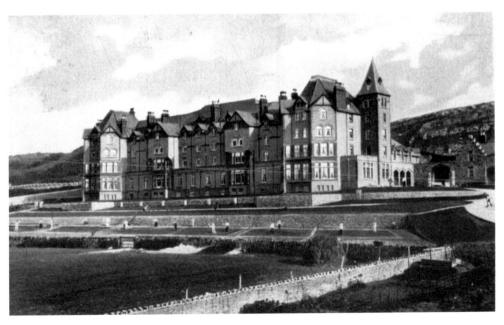

This impressive building stood on the road over the Little Orme. The Craigside Hydro occupied this site for nearly one hundred years before it was demolished in 1974. There were several outdoor tennis courts between the hotel and the road, and there was also an indoor court across the road from the main building, where national and international competitions were held.

Penrhyn Isaf Farm is one of the old farmsteads that has existed for centuries in this area. Penrhyn Isaf Road takes its name from this farm.

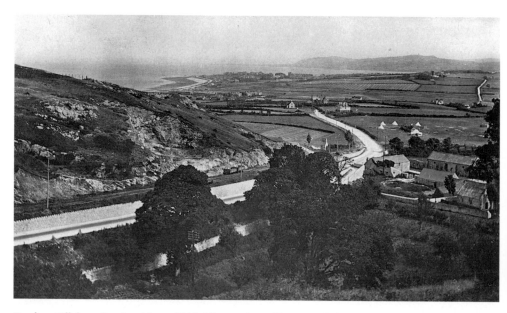

Penrhyn Hill from Penrhynside, c. 1912. The number of houses and the road configuration have changed considerably since then. The busy modern road bordering the golf course leading to Llandrillo church was not built until 1922. The main thoroughfare here is St David's Road and Penrhyn Isaf Road. The Old Hall farm buildings are on the right of the photograph, and at the bottom of the tram track there are railway sidings for the Little Orme quarry.

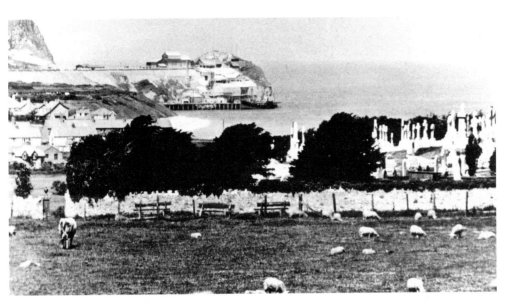

Little Orme Quarry, *c.* 1930. This telephoto view has greatly foreshortened the perspective of the scene. The cemetery on the right is that of Llandrillo-yn-Rhos church. The most interesting aspect of the photograph is the quarry on the Little Orme in the background. Quarrying of limestone on the north-eastern face of the headland went on from 1889 until the 1930s in two distinct stages. A boat is being loaded with limestone at the quarry dock.

Quarry workers, *c.* 1900. In 1896 fifty men were employed in the Little Orme Quarry and twenty-nine men were outworkers. It was an essential source of employment for the men of Penrhynside village. The good quality limestone was shipped directly to the Clyde for use in the blast furnaces and chemical works of the industrial north-east. The company, founded in 1889 by Joseph Stony and his son Robert, went into liquidation in 1913 and was wound up in 1914.

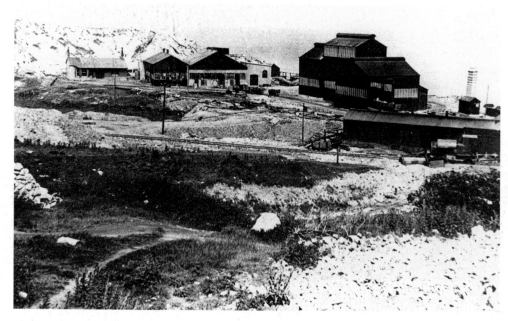

The quarry re-opened in 1920, and the undertaking was eventually greatly expanded and modernized. 67,000 tons of limestone were quarried annually; eighty-seven men were employed in the quarry and forty-five outside. This photograph was taken after the modernization which occurred in 1927. There were eight working narrow gauge steam trains on the site. Work ceased there altogether in 1931.

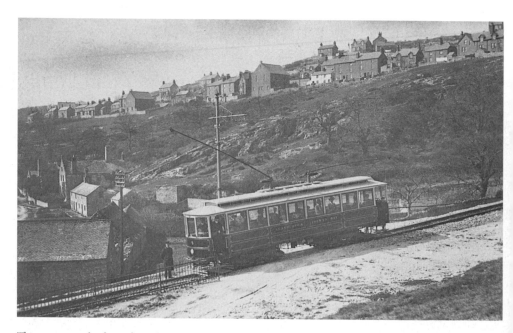

This tram is at the foot of Penrhyn Hill, *c.* 1910. In the background is Penrhynside village and to the left is Penrhyn Old Hall.

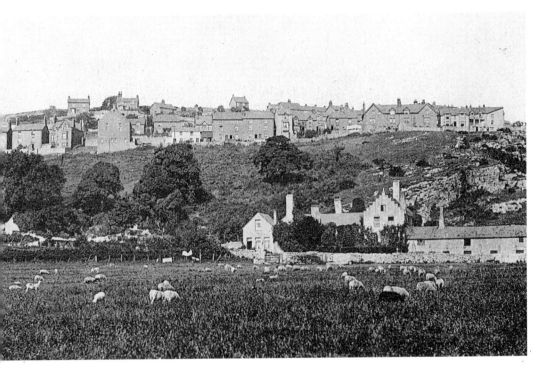

Two views of Penrhynside village, *c*. 1900. The village clings to the slopes of Penrhyn Hill above Penrhyn Old Hall. It was originally a quarry workers' village, the men working in the limestone quarry on the Little Orme until production ceased in 1931.

Penrhyn Old Hall, *c.* 1920. Ghosts, hanging, drawing and quartering, a skeleton and a severed hand are all part of the history of this, one of the oldest buildings in North Wales. The house was mentioned by Leland in 1549 after his itinerary through North Wales. In Elizabethan times the house was owned by the Pugh family, a staunch Roman Catholic family. There was a chapel in the grounds with a resident priest. A thwarted conspiracy to murder the protestants on the Creuddyn in 1585 was followed by the escape of the conspirators. The priests escaped for nearly a year and hid in a cave, Ty-yn-y-Graig, on the Little Orme. In this cave they operated a printing press, and the first book to be printed in Wales was printed here: *Y Drich Cristionogawl* (*The Christian Mirror*). Their presence here was eventually discovered and they fled, only to be captured at Holyhead attempting to get to Ireland. A priest, Father William Davis, was hanged, drawn and quartered in Beaumaris Castle in 1593. His severed hand was said to have been preserved by the Pugh family, and when the family left the Hall, many years later, a withered hand was discovered in a trunk they had abandoned.

In the eighteenth century one of the sons of the family disappeared after a family quarrel concerning inheritance. Many years later the complete skeleton of a man was found in a lime kiln alongside the house. Two ghosts are said to haunt the Hall to this day. A young female descendant of the Pugh family has been seen on the stairway; she was murdered to prevent her marriage to a protestant. And a monk is said to walk about upstairs above the Baronial Hall.

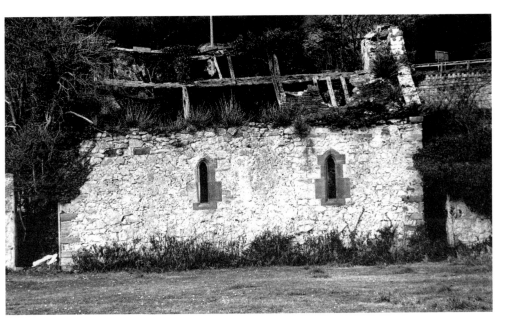

This chapel is in the grounds of Penrhyn Old Hall and is believed to be the original St Mary's Chapel, built in 1447. It has had a chequered career: once it was used for boiling pig-swill, and it has also been used as a stable. For many years it has lain derelict and neglected. This photograph was taken in 1997.

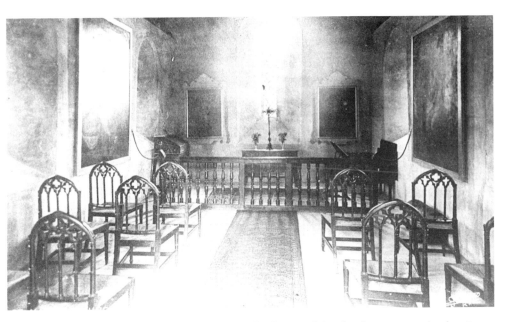

St Mary's Chapel interior, 1926. This was the year the dignity of the church was restored, when it was renovated; it was used as a place of worship by local people until 1930. A new church was then built in St David's Road and the congregation moved there. The building has reverted to its neglected condition, a shameful state for such an historic church.

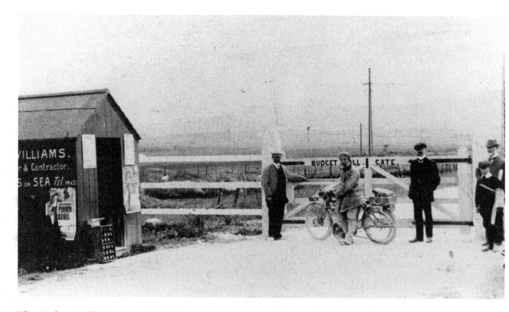

The Budget Toll Gate, *c.* 1909. This gate was erected by William Horton at about the time that this photograph was taken. He used the tolls to pay the taxes imposed by Lloyd George's Pensions Act of 1908. The road was bought in 1911 by the tram company, which continued to exact tolls until 1963. Cars were 1*s*, horse and cart 1*s*, a baby in a pram 1*d*.

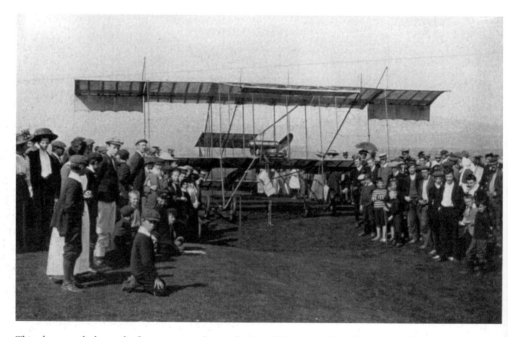

This photograph shows the first ever aeroplane to land in Wales. It touched down in Penrhyn Bay on 1 August 1910. Thirty-four-year-old Robert Loraine landed his Farman biplane safely on the golf course after flying from Blackpool 63 miles away. He had completed a record-breaking over-sea flight.

SECTION NINE

ENTERTAINMENT

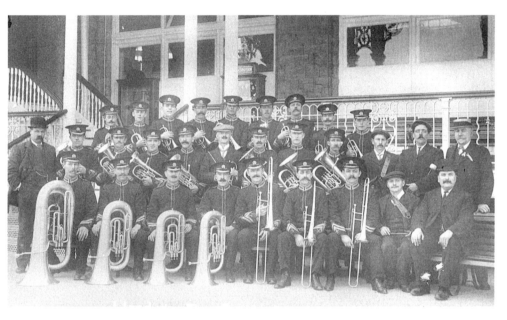

The town band outside the Pier Pavilion, c. 1920. The band played in the Happy Valley Amphitheatre on Sunday afternoons for many years. In the early years of the century the band played in a wheeled bandstand. This was moved from place to place between performances, pulled by a team of horses (see p. 51). Nowadays there is a permanent bandstand on the promenade.

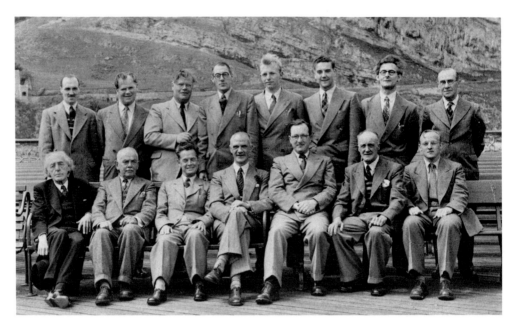

John Morava and the Pier Orchestra, *c.* 1950. In 1938 John Morava became Musical Director of the Llandudno Pier Company. He gave of his time unstintingly to local amateur ensembles, for example the Llandudno Operatic Society and the Colwyn Bay Choral Society. In all, he completed thirty-seven seasons on the Pier and performed in some 10,000 concerts. In 1974 he conducted his farewell concert, and his departure was the beginning of the end for the orchestra.

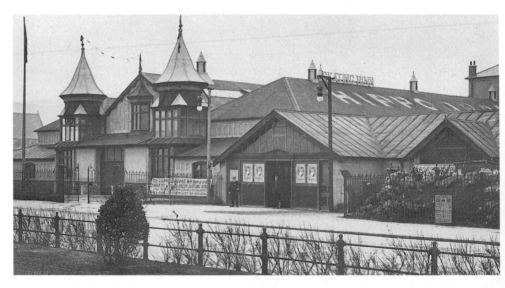

The Hippodrome Skating Rink, 1909. This building had been constructed as part of an entertainment complex that included a second Llandudno Pier at this point. The plans for the pier were abandoned but a 1,200 seat theatre remained. The name changed from the Victoria Palace to Rivière's Concert Hall; then, in 1900, it became Llandudno Opera House and eventually the Arcadia Theatre.

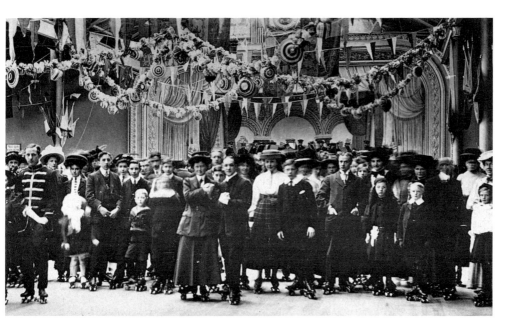

Above: Interior of the Hippodrome Skating Rink, 1908. The boarded floor and the primitive roller skates must have generated a considerable noise and clouds of dust! The skating rink venture did not last long and the building reverted to being a theatre in 1915.

Left: John Philip Sousa, September 1903. The American March King visited the Hippodrome at this time with his world-famous Sousa's Band, on one of his several European tours. He composed over 130 marches before he died in 1932.

99

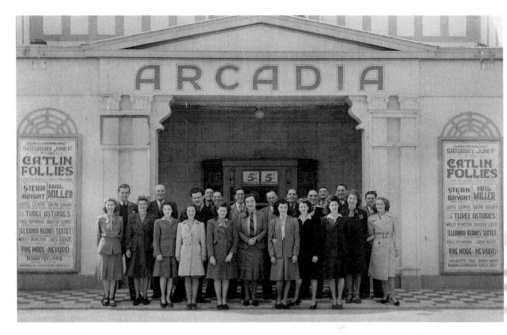

This photograph of the Arcadia Theatre was probably taken in the 1940s. The theatre had been purchased in 1915 by the self-styled 'Great Showman' Will Catlin (1872–1952). The Hippodrome was pretty much derelict at this time, and Catlin refurbished it and renamed it the Arcadia. In more recent times the shows at the Arcadia have been produced by Robinson Cleaver and Clive Stock. In the late 1960s the theatre became the property of the Llandudno Urban District Council, later Aberconwy Council. It is now closed.

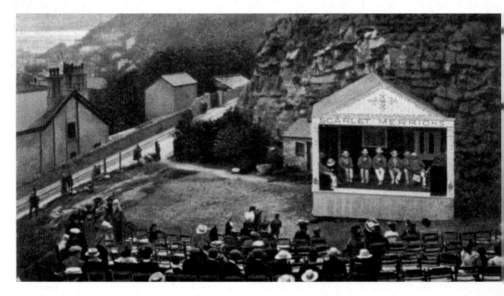

A group of minstrels called the Scarlet Merrions performing in Faulke's Cave on the Great Orme's Head, c. 1910. In the early days of the town's history entertainment seemed to lie around every corner. Seaside entertainment was a *sine qua non* of the holiday scene; sadly this is no longer the case.

This evocative photograph of 1903 revives memories for those who have watched and listened to the colourful and screech-voiced, wife-beating, baby-batterer over the years. The puppeteer is Richard Codman, whose family have been part of the life of the Promenade for well over 100 years. They ran a similar show on the forecourt of Lime Street station, Liverpool.

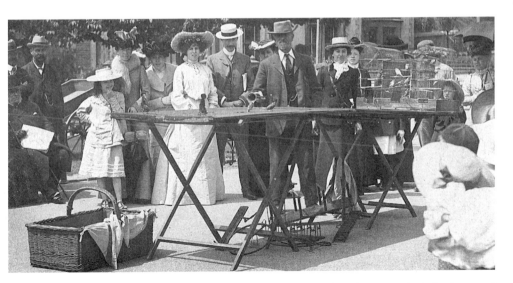

Ferrari's Performing Birds, c. 1910. Mr Giciano Ferrari was born in Italy and came to Llandudno by way of Brighton. Apparently the birds were at their most entertaining when they went on strike, and they would accompany Ferrari's dance of rage with screeches of derision from the branches of the nearby trees. He would launch a cockatoo from the table, and it would fly away and circle the Grand Hotel before returning. Ferrari died in 1923.

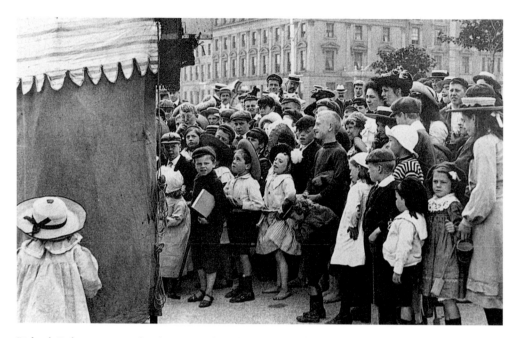

Richard Codman is reputed to have arrived in Llandudno in 1864, in a gypsy caravan, staying because his horse died. To earn a living he picked up driftwood on the shore and from it carved his first set of puppets. His early shows aroused the ire of the Improvement Commissioners and in 1864 'Punch and Judy, his dog and all the noisy paraphernalia belonging thereto' was banned. He struggled hard to get the ban removed, and eventually succeeded. There is a puppet man in *The Old Curiosity Shop* by Charles Dickens, and his name is Thomas Codlin. It is alleged that Dickens used Richard Codman as a model for his character. Professor John Codman presented the Punch and Judy shows on the promenade for forty-one years and he never missed a season. He died in April 1980.

This production of *Our Flat* by the Llandudno Amateur Dramatic Society (LADS) in 1901 was the company's first production. Back row, left to right: Messrs C.A. Hutton, A. Clevere Slater, Billy Lloyd, Harry Crockatt, Tom Jones (Prince's Theatre), Harry Parker. Seated: Miss Nell Roberts, Miss Bessie Brookes, Mrs C.A. Hutton, Miss Fanny Sumner, Miss Annie Davies, Miss Nancy Dawson. Front: Messrs Bert Jester and James Turner.

In the late 1920s the LADS' production was *At Mrs Beanes*. The cast from left to right is Miss Nellie Margetts, Miss Edith Holroyd, Mrs Nellie Martin, Mrs Ernest Fleet, Mr Leonard Bond, Miss May Margetts, Mr D. Wynne Roberts, Miss Nellie Brown, and Mr Ivor Roberts. By 1930 LADS had produced eighty-one plays.

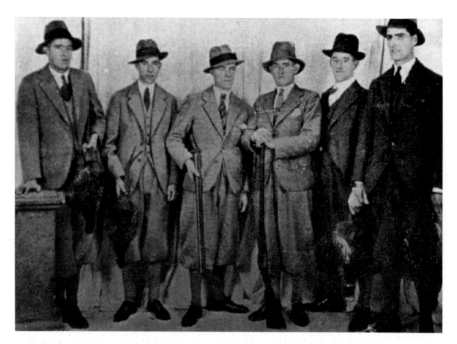

An amateur ensemble which is still going strong is the Llandudno Musical Players Society, and this is their production of *A Country Girl* in 1932. The male members of the cast from left to right are Frank Evans, Walter Cleeve, Jack Pickup, Jack Parsons, Rupert Spencer and Rowley Statham.

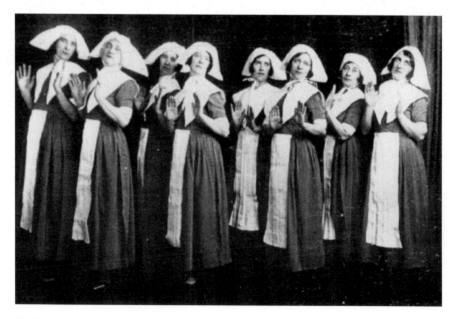

The Quaker Girl was the 1930 production of the Llandudno Musical Player's Society. The Quaker girls in the photograph are back row, left to right: Kathleen Jones, Olwen Jones, Jenny Lunt, Edith Jones; front row: Nellie Singleton, M. Bailey, Annie Robinson, Vaughan Edwards.

SECTION TEN

THE LIFEBOAT

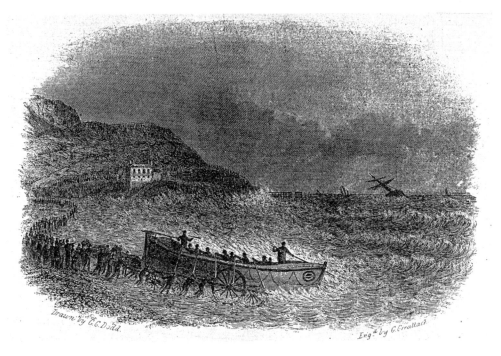

An engraving of the Sister's Memorial (1861–7). Named in memory of one of the sisters of the Misses Brown of Liverpool, the Sister's Memorial was Llandudno's first lifeboat. The boat was narrow in the beam and sharp in the bow, and was prone to capsize. In an incident off Rhyl the crew were lucky to escape with their lives. The coxswain was a copper miner named Hugh Jones. In 1867 she was replaced by Sister's Memorial II, which was operational for twenty years and saved thirty-five lives.

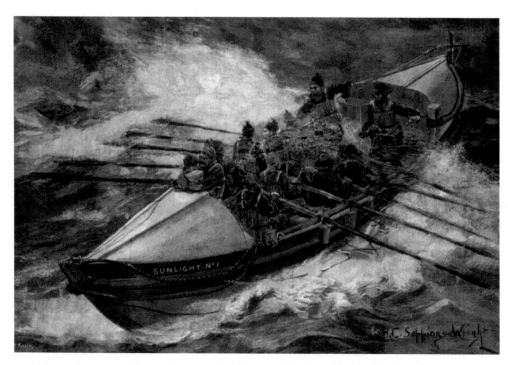

In this engraving from the *Illustrated London News* we see *Sunlight No. 1* (1887–1902). This boat arrived in Llandudno in 1887 and was sponsored by Lever Brothers, the soap manufacturers, who were astute enough to call her after one of their popular soap brands. In her time she saved twenty-six lives, but was considered to be an unlucky boat. Two men were killed, in separate incidents, when she was being pulled by horses to the shore. She was replaced in 1902.

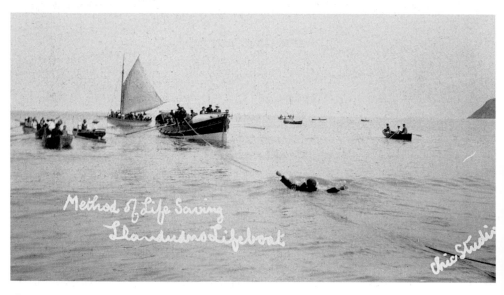

The *Theodore Price* is demonstrating life-saving techniques to the holiday crowds in 1907.

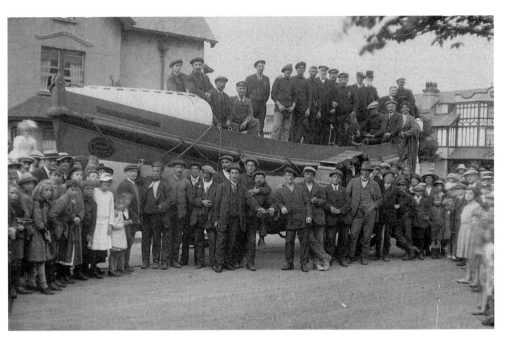

Pictured here in 1902 on her arrival at the town is the well-loved *Theodore Price*. Considered to be Llandudno's 'own', she was designed and built according to specifications drawn up by three of the crew: Coxswain John Hughes, Deputy Cox John Williams and John Owen (who later became Cox and was the only member of the crew to receive an RNLI medal).

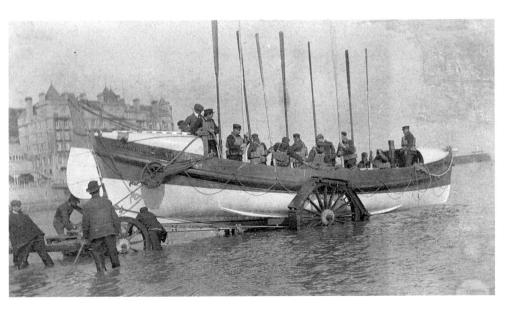

An interesting photograph of the launch of the *Theodore Price*, *c.* 1910. She was 37 ft long, 9 ft 3 in beam and carried ten to twelve oarsmen. In her time she was called out forty-two times and saved thirty-six lives. She had completed twenty-eight years of valiant service before she ceased operating in 1930.

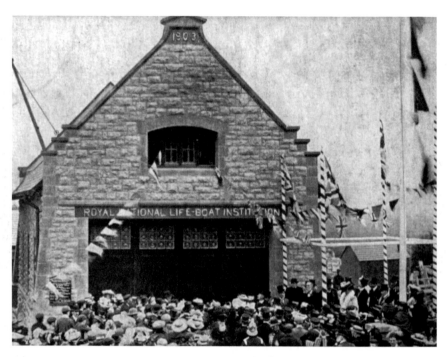

The 'new' lifeboat house was build halfway between Llandudno's two shores so that the boat would be readily available for either of them as required. It was built in 1903, and this photograph was taken at the formal opening by Lady Mostyn. The total cost for the house was £1,300. In 1983 it was extended and opened by Mr George Scarth, in memory of Edith Annie Scarth.

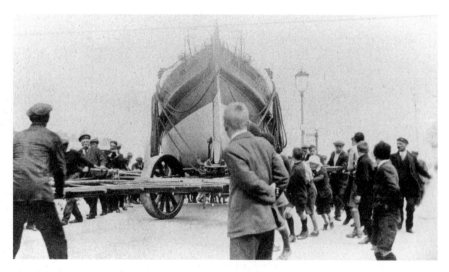

When the boat was called out she had to be dragged through the streets to the launching point. Horses would arrive at the boat house to draw the boat to the shore; the cost was 5s per horse. All too frequently there were no horses available, and the townspeople had to rally around and pull on the ropes attached to the undercarriage, as in this photograph.

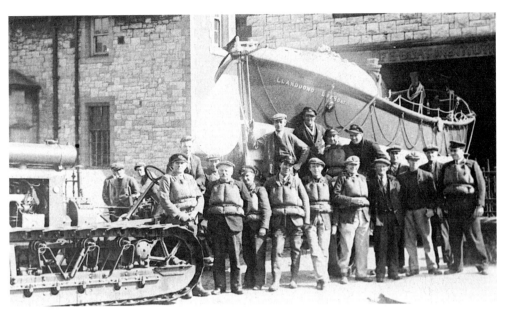

The *Thomas and Annie Wade Richards* was the lifeboat for the twenty years from 1933 to 1953. Funding was made available through two legacies (D. Thomas Richards of Carmarthen and Mrs Sarah Lewis of Aberystwyth). Costs have now risen astronomically and the boat cost £4,000. She was 35 ft long with a beam of 9 ft 3 in. She was officially launched on Friday 28 September 1934, but before this had already saved six lives. During her lifetime she saved forty lives. In this photograph we see the tractor which, from this time, pulls the boat to the shore.

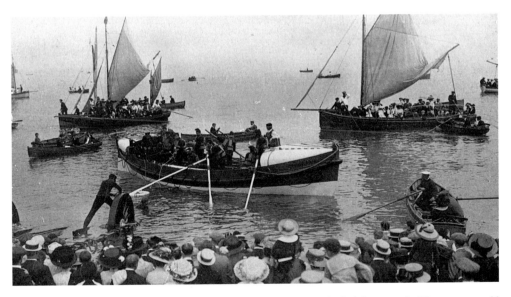

The launch of the lifeboat always sparked great excitement among the holiday crowds. The crews would encourage this interest by demonstrating their considerable life-saving skills. Collections taken during these practice and display sessions provided some funding for the service, as they still do.

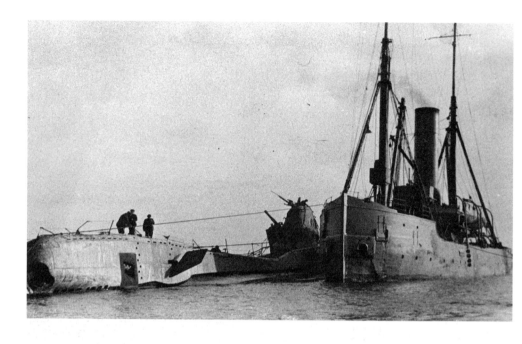

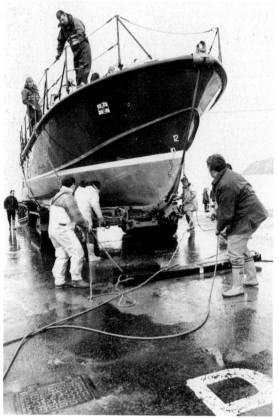

Above: Probably the most dramatic call received by the *Thomas and Annie Wade Richards* was on 1 June 1939 when she was called to the stricken submarine *Thetis*, 14 miles off the Great Orme's Head. Dr A. Maddock Jones of Llandudno was aboard, as requested, but the voyage was in vain. Ninety-nine men died in terrible circumstances.

Left: The double-maroon still goes off in Llandudno, as it always will. The modern lifeboat with its sophisticated radar equipment and its dedicated crew is always available, helped by the smaller, lighter and more manoeuvrable inshore boat.

SECTION ELEVEN

THE TRAM ROUTE

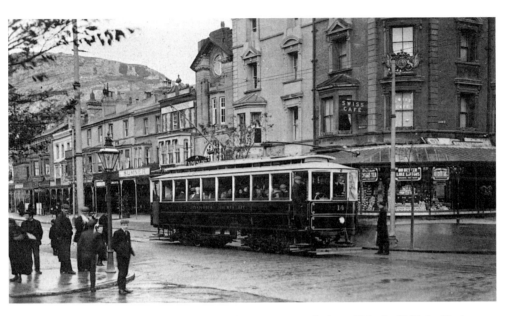

This photograph shows tramcar no. 14 on a very early trip along Mostyn Street. The date is 19 October 1907, the official opening day of the service. A limited, experimental, service had been introduced on 26 September 1907 after a Board of Trade inspection.

The old tram station on the West Shore was erected in 1907 at the instigation of the Llandudno and Colwyn Bay Electric Railway Co. Ltd. The last tram left this terminus some fifty years later in 1956. The station had been neglected for many years and was in danger of dereliction, but a local council initiative led to it being rebuilt.

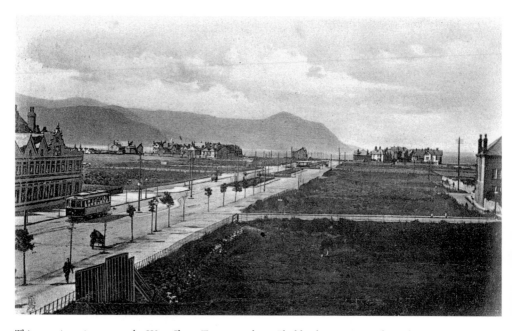

This tram is on its way to the West Shore Terminus along Gloddaeth Street away from the town centre. This section of the town is undeveloped at this time, probably about 1910. The tram is going through the last loop in the system before it reaches the terminus.

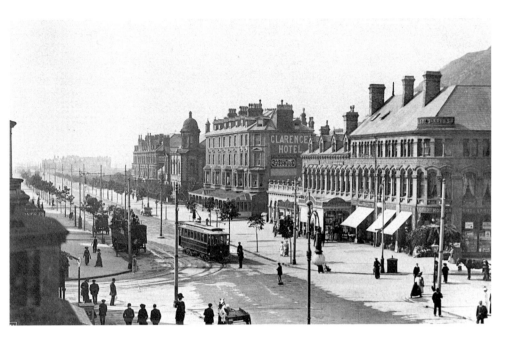

This shows the sweep of the tram track from Gloddaeth Street into Mostyn Street. Behind the tram, outside the Clarence Hotel, is an early motor car. The horse transport to the left of the tramcar makes this photograph an interesting illustration of transport in transition.

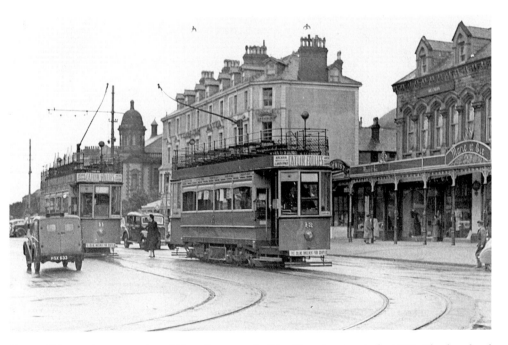

Car no. 13 is entering town and no. 11 is on its way to the West Shore terminus in the 1940s. The sharp bend in the track into Mostyn Street is seen clearly here.

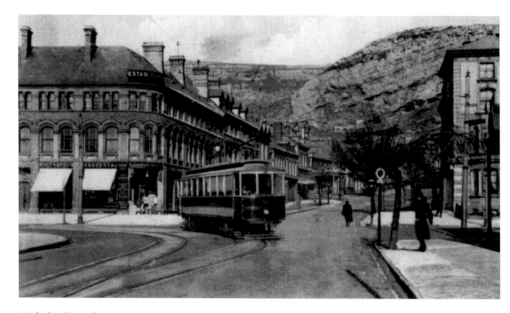

With the shop of T. Esmor Hooson behind it, no. 11 rounds the corner from Gloddaeth Street. This was a very sharp bend, and there were constant complaints about the noise made by the trams as they squealed around this corner. One councillor at a meeting of the Llandudno Urban District Council in 1911 described the noise as being 'like the shrieking of Kilkenny cats'. Assurances were given that this noise would be cured by liberally greasing the rails.

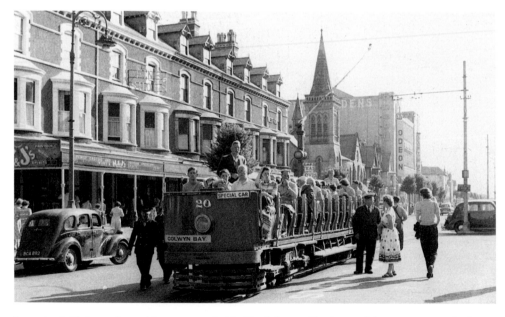

Inspector A.M. Jones chats with a passenger in Gloddaeth Street. The driver of this tram is a popular figure, Richard Hughes ('Farmer Dick'). The Odeon cinema in the background has been demolished and replaced by residential accommodation.

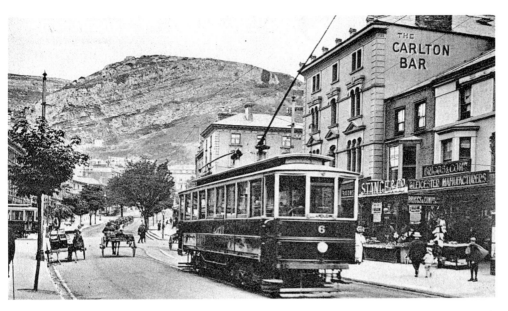

Car no. 6 is outside the Carlton Hotel, and is approaching Hooson's Corner to begin its run up to Gloddaeth Street. This was one of the fourteen single-deck cars which began the service in 1907. Another tram is beginning to nose its way around the corner into Mostyn Street. The pony and trap to the left of the tram belongs to the town crier, who also conducted business as a porter.

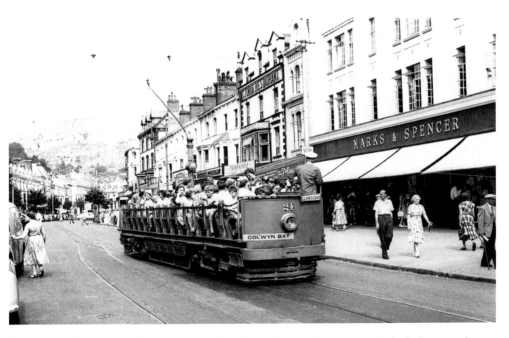

This relatively late photograph shows car no. 21 in Mostyn Street. The open-top single-deckers were known as 'toast racks' for obvious reasons, and they are remembered with a great deal of affection. The driver of this car is the late Mr Reginald Johnson who awaits the whistle to proceed.

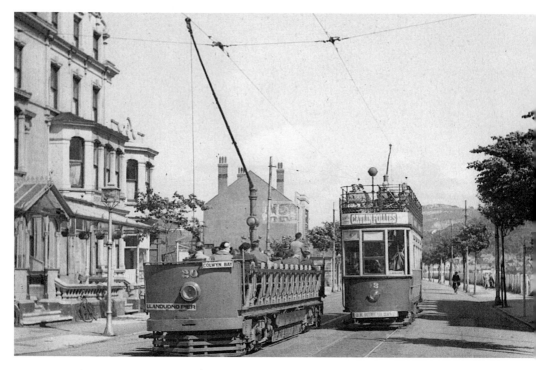

A toast rack (no. 20) and an open-topped double-decker (no. 13) meet on the track in Mostyn Avenue. No. 20 is on its way to Craig-y-Don and no. 13 is entering town.

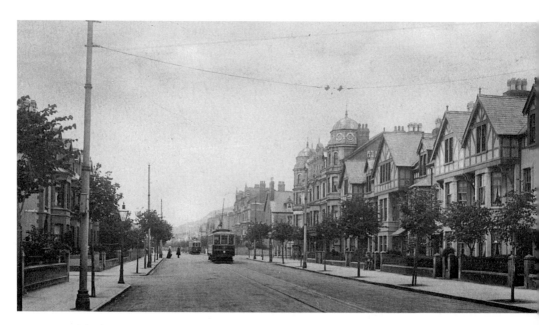

Two of the first fleet are on the Mostyn Avenue track in Craig-y-Don. The track is still a single one in this photograph; it was doubled in the years 1912–13.

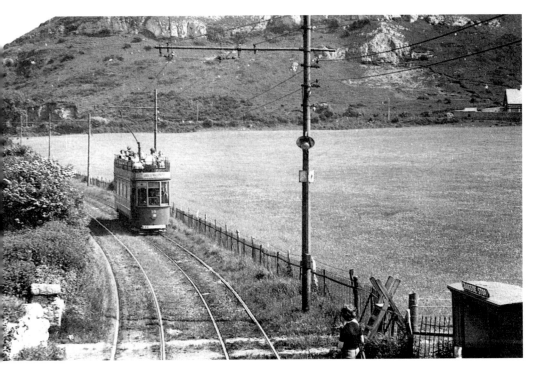

The route takes on a distinctly rural aspect as the tram crosses Bodafon Fields. The tram here is approaching the Craigside stop with Penrhyn Hill in the background.

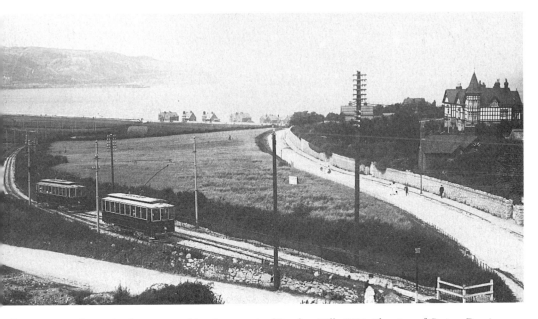

Two trams on the passing loop approaching the summit of Penrhyn Hill, 1909. The view of Craig-y-Don in the distance shows that the area was undeveloped at this time.

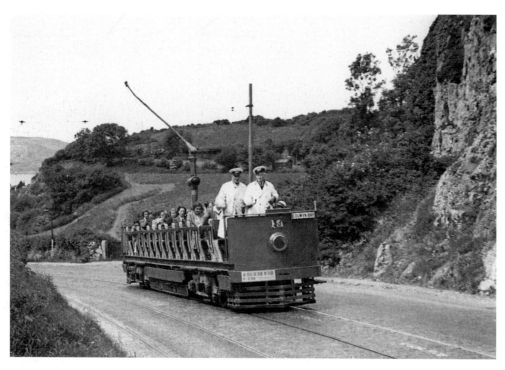

A 'toast rack' climbs the relatively shallow gradient of the Llandudno Bay side of the Little Orme, just before the Second World War. Mr Robert Cain accompanies a fellow driver.

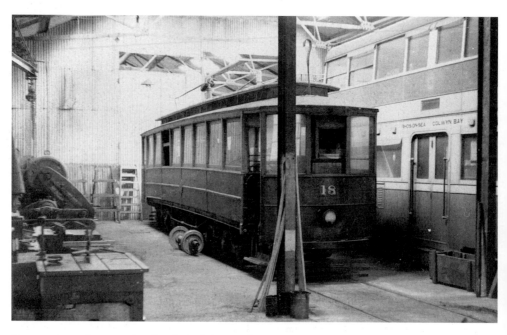

Tram repairs underway at the Church Road depot, Rhos-on-Sea.

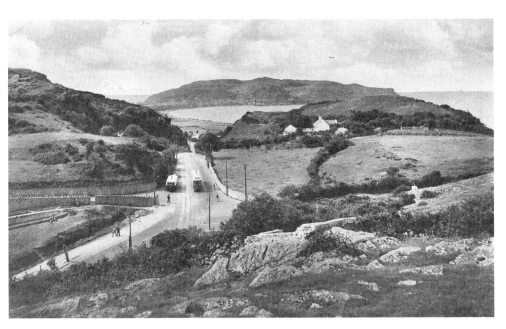

A bus and a tram share the same stop at the top of Penrhyn Hill, 1954. The Great Orme in the background provides a picturesque backdrop for this view.

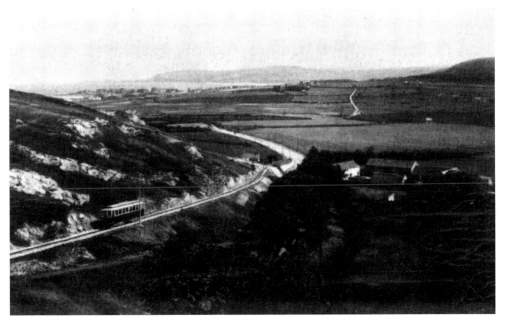

The shelf blasted into the side of the Little Orme to reduce the steepness of the gradient (1 in 11) into Penrhyn Bay can be seen clearly in this early photograph. The ordinary traffic route is below it. There is little housing development in Penrhyn Bay at this time, but the outbuildings of the Penrhyn Old Hall Farm can be seen on the right.

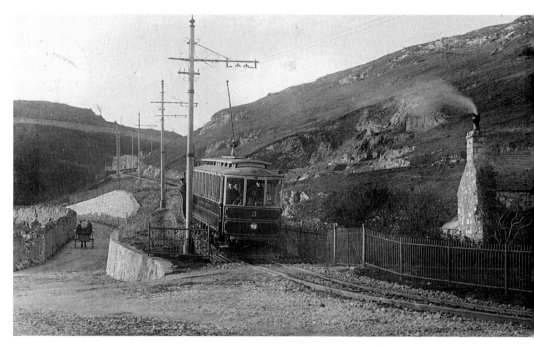

Car no. 3 descends the steep gradient of Penrhyn Hill. The route for ordinary road traffic is to the left of the tram track.

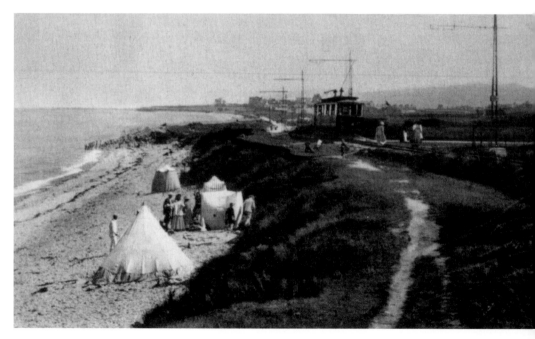

The track runs alongside the shore at this point in Penrhyn Bay. Over the years this stretch of the track presented serious problems owing to the erosion caused by the encroaching sea.

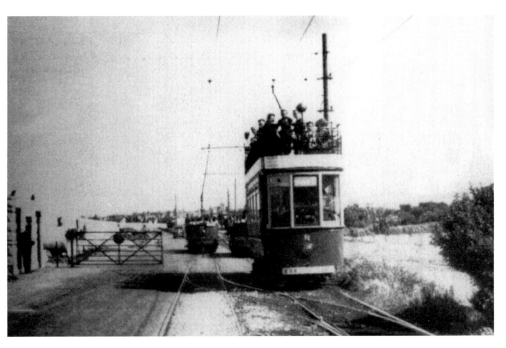

A busy scene at the toll gate on the shore road in Penrhyn Bay. The tram company bought the road in 1911 and the tolls were charged by them up until 1963. The tram (no. 8) in this picture was the last tram on the route in 1956.

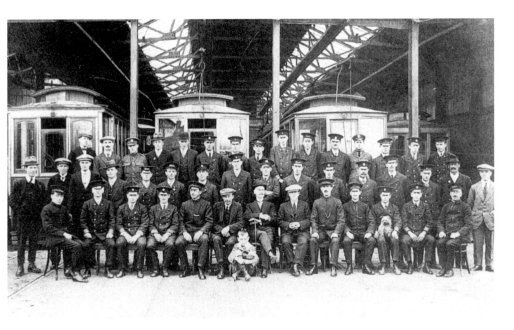

The assembled staff of the Llandudno and Colwyn Bay Electric Railway Co. Ltd pose for a photograph outside the Church Road depot, Rhos-on-Sea, 1919. The tram depot is now the depot of a national freight company.

The driver of this tram outside the Caley Arms in Rhos-on-Sea is 'Farmer Dick'. The crowded tram is an indication of the popularity of the 'toast rack' service in good weather.

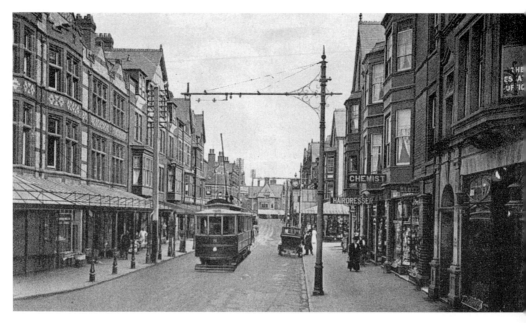

Shortly after the Llandudno–Rhos-on-Sea route came into service the track was extended into Colwyn Bay. Car no. 8 moves through Colwyn Bay's main street on a single track. It is worth noting that this now very busy road is virtually traffic free.

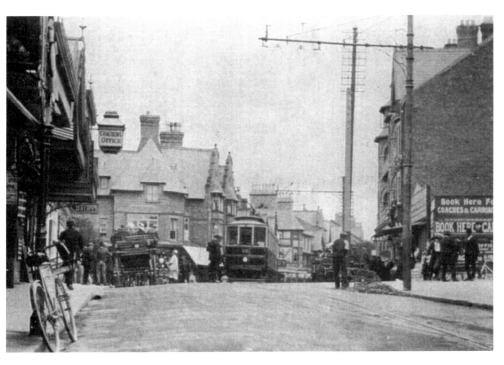

This busy scene shows the terminus at the top of Station Road in Colwyn Bay before the route was extended.

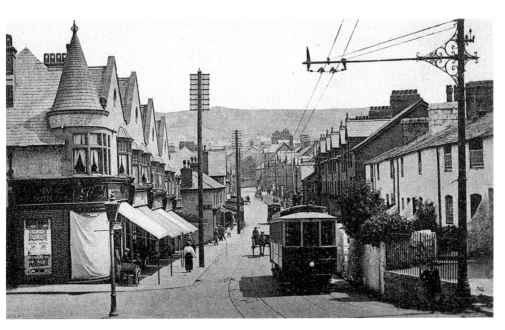

This car is running on the extension to Old Colwyn which was opened in 1913. The Old Colwyn section of the route was the first to disappear in the 1930s and was taken over by local bus services. The cottages on the right were known as Plough Terrace and have now been demolished.

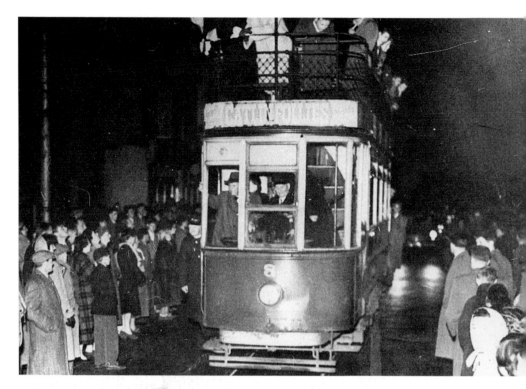

There were several causes leading to the demise of the Llandudno and Colwyn Bay Electric Railway. Conflicts concerning the cost of generating power, competition from the internal combustion engine, road congestion and so on all played their part. The last tram, a double-decked no. 8, ran on 24 March 1956. The driver was Inspector Fred Wooley. It was estimated that during the fifty years of its life the company had transported 130,000,000 passengers.

SECTION TWELVE

GREAT ORME TRAMWAY

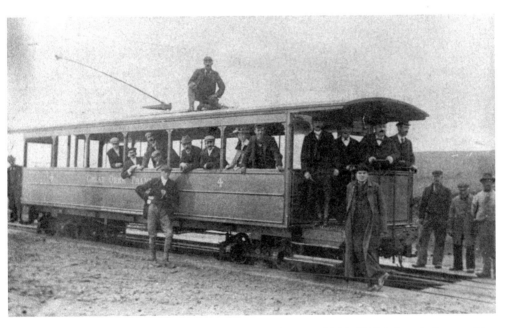

This photograph was taken on the day of the Great Orme Tramway's opening, 31 July 1902. It shows the directors of the company and the tramway staff at the top of the lower section of the system. As the first car moved away the town band played 'God save the King' and the small crowd of townspeople cheered. By 8 October 1902 the line had carried 70,000 passengers. The top section of the system opened on 8 July 1903.

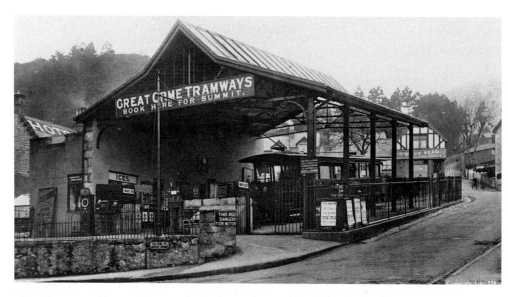

This is the Victoria station and ticket office of the Great Orme Tramway. It is the start of the longest funicular (cable) railway in Great Britain. The station derived its name from Victoria House, which was demolished in 1901 when work started on the 3 ft 6 in gauge railway.

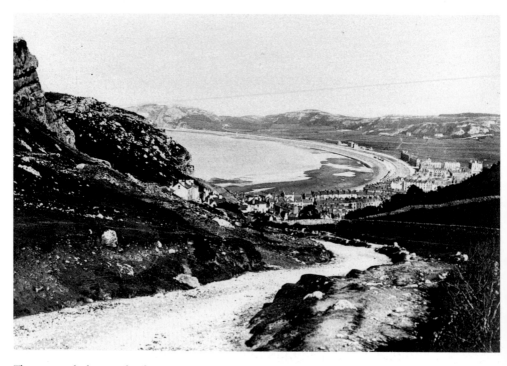

There is very little town development in the background of this early view, and, in the distance, Craig-y-Don is almost non-existent. Miners trudged up this path to their work and this was later the route of the Great Orme Tramway.

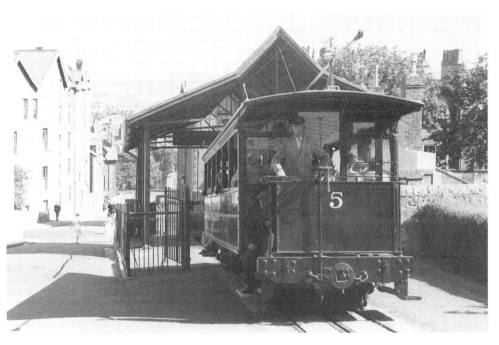

Tram no. 5 is leaving the station and beginning its ascent up the first of the two-part journey to the summit. The journey is in two parts because it is too long a distance for a single draw cable.

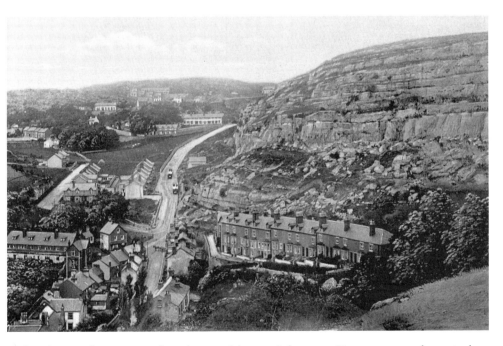

Looking down on the tramway in the early years of the twentieth century. Two trams are on the passing loop in Ty Gwyn Road.

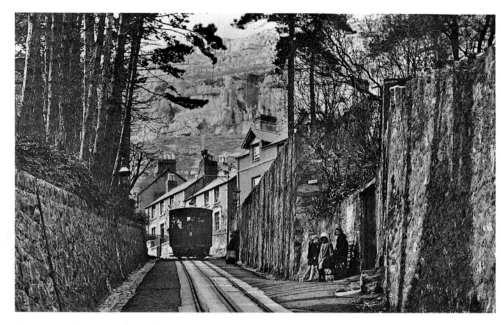

Car no. 5 is on the first part of the steep journey through the narrow passage leading to the Black Gate. No other traffic is allowed on this section.

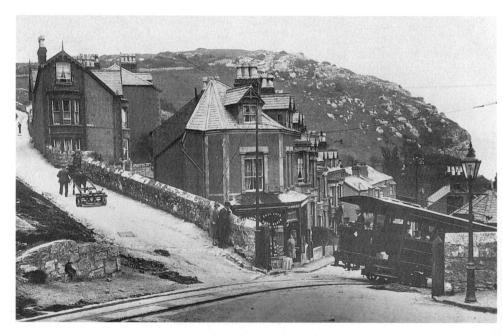

The Black Gate entrance is where the tram track crosses Old Road and Tygwyn Road. Up to this point the gradient has been about 1 in 4.4, and at one point 1 in 3.6. The steepness can be seen in the angle of the car's roof as it approaches the crossing. The horse pulling the mower on the left is probably on its way to cut the fairways on the pitch-and-putt course above Happy Valley.

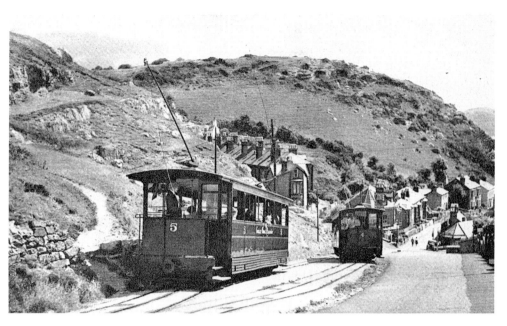

At the top of Tygwyn Road, just after the Black Gate, there is a passing loop, seen here. The poles on the top of the cars are not the power units as in electric trams; they allow for telegraphic communication between the cars and the two stations.

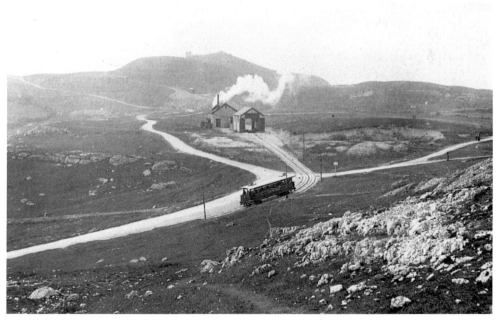

A tram is approaching the half-way station, 1913. The tower of the summit building can be seen in the distance. The smoke rising from the engine-house boilers is providing steam to power the system.

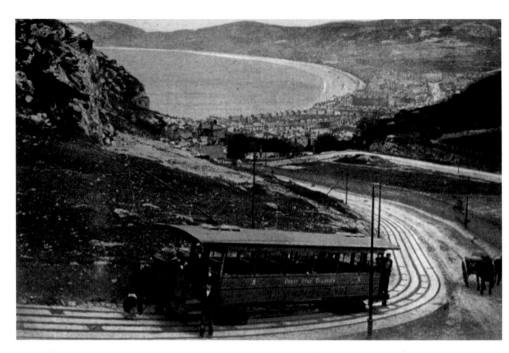

This tram has stopped for some reason, but it is well on its way to the halfway station, which is 489 ft above sea level. There is an excellent view of the town and bay from this point.

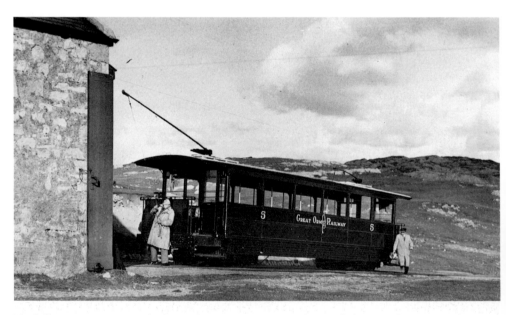

The halfway station is 872 track yd away from Victoria station and is 400 ft above it. This station is the engine room of the system. It contains two colliery type winding engines. The lower section engine is 120 horsepower and the upper section is 60 horse power. It is at this station that passengers have to disembark and change trams for the continuation of the journey to the summit.

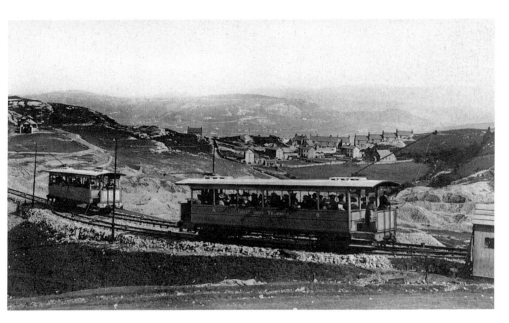

The gradient is now less steep as the cars are nearing the summit. The photograph is dated 1911, when the power for the system was provided by steam engines in the halfway house. In 1957 this was changed to electric power, which was much less troublesome and cheaper. Before 1957–8 250 tons of coke a year were burned at a cost of £7 a ton.

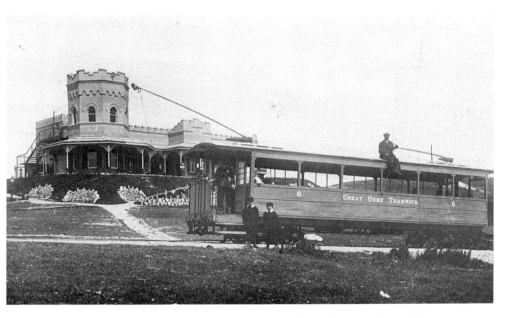

The tram has reached the Summit station with the Summit Hotel in the background, c. 1910. Passengers are now free to roam the slopes around the summit and take in the magnificent views before returning to the town.

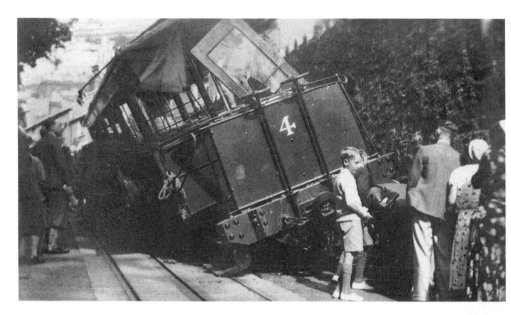

On Wednesday 23 August 1932, when car no. 4 was descending on the steepest part of the run, the drawbar connecting the car to the cable snapped. Subsequently the brakes failed, and the car left the rails and smashed into a wall. As the top of the tram swept along the top of the wall it removed the coping stones which crashed through the windows on to the passengers inside. Fifteen people were injured: eleven of them were kept in hospital for treatment. The brakeman, Edward Harris, aged thirty-five, and a twelve-year-old girl, Margaret Worthington, were killed. Damage claims forced the company to be wound up, yet the tramway remained open and changed hands in 1934. In 1948 the system was bought by Llandudno Council, which still runs it. The picture below was taken very soon after the accident happened.

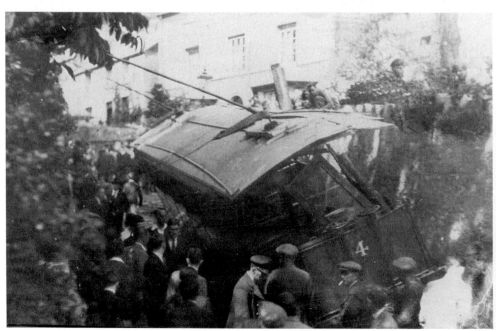

SECTION THIRTEEN

STEAMSHIPS

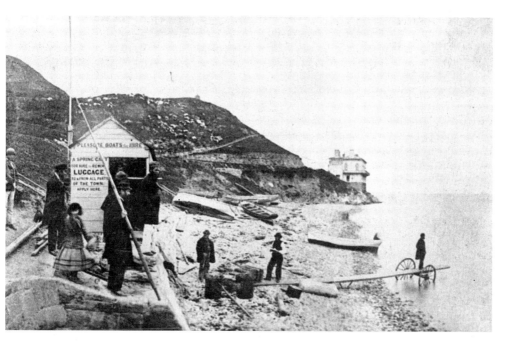

In this very early photograph carriers are awaiting the arrival of the steamer. There is no pier and only a primitive jetty. The Baths Hotel is in the background. The steamer would anchor in the bay and the passengers would be rowed to the shore in small boats. The porters then carried them and their luggage to the beach. An interesting feature of this photograph is the wooden hut, which is reputed to be the hut in which Owen Williams and Lord Mostyn held their historic meeting in 1844.

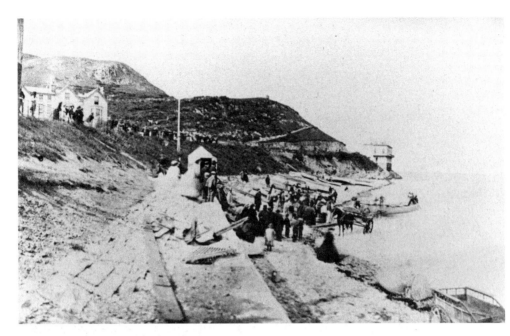

The people in this early view are waiting for the steamer to come back from the Menai Straits on its return journey to Liverpool. Steamer-sailing along the North Wales coast has a long history, starting with the St George Steam Packet Co. in 1821. In 1843 the City of Dublin Steam Packet Co. took over. The major company to serve the coast for many years up until 1962 was the Liverpool and North Wales Steamship Company Ltd, founded in 1891.

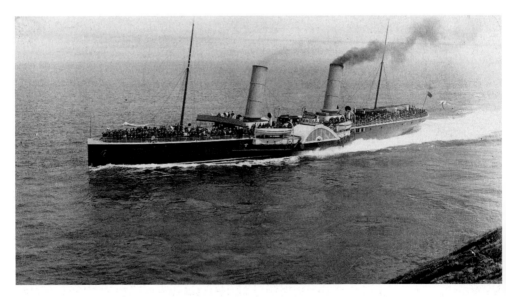

The *St Tudno II*, seen here passing Bull Bay in Anglesey at the turn of the century, is one of the most notable of the Liverpool and North Wales line ships. She was built in 1891 and could carry 1,061 passengers. She was sold in 1912 and broken up in 1922.

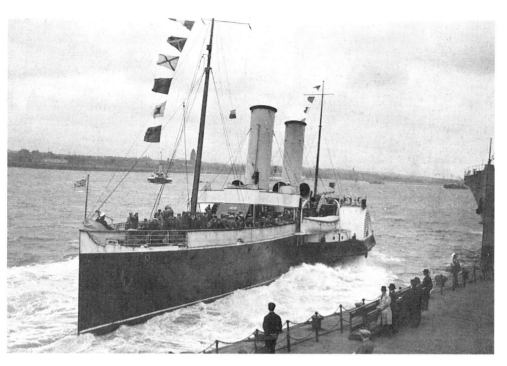

This interesting photograph was taken in 1930 and shows the *St Elvies* starting her final voyage to the North Wales coast. She was built in 1896 and was brought in to replace *Bonnie Prince*. She became a very popular boat and could carry 991 passengers. The *St Elvies* was broken up soon after this photograph was taken.

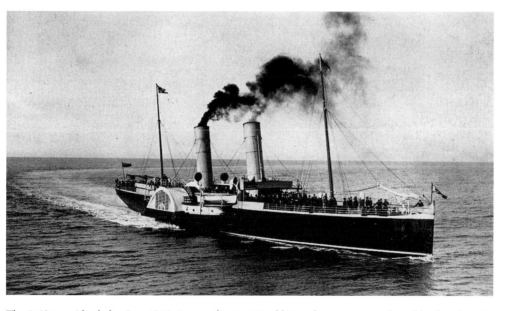

The *St Elvies* in Llandudno Bay, 1912. During the First World War she was commandeered by the admiralty and served as a mine sweeper.

The SS *Snowdon*, *c*. 1908. She was built in 1892 and became part of the Liverpool and North Wales fleet as the result of a merger with the Snowdon Passenger Steamship Company. She carried 462 passengers. In 1931 the ship was sold and broken up.

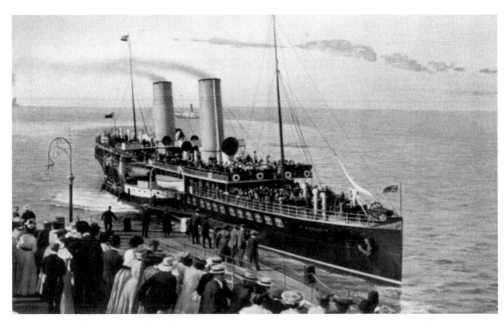

The much loved *La Marguerite* is approaching the pier at Llandudno. She was built in 1894 by Fairfield Co. of Govan, and worked out of the Port of London for eight years before being bought by the Liverpool and North Wales Co. in 1904. She was the biggest excursion boat of her time. She had a gross tonnage of 1,554, was 341 ft in length and could carry over 2,000 passengers when full. There were days when she carried as many as 1,000 day trippers into Llandudno.

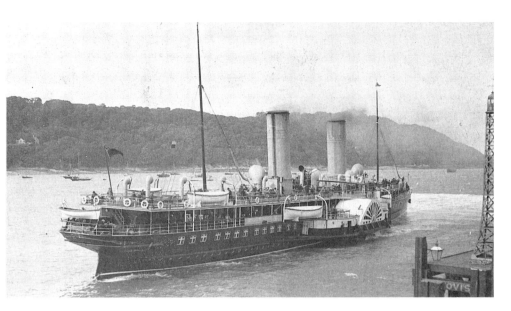

La Marguerite, seen here leaving Bangor Pier in 1907, was easily the most popular steamer ever along the North Wales coast; she was called a floating palace. During the First World War she was used as a troop carrier across the Channel, and many a Tommy took his last look at his homeland from her decks.

Posted in 1913, this postcard assures the recipient 'We are having a ripping time in Llandudno'. The crowds are boarding *La Marguerite* and she is probably on her way back to Liverpool at the end of the day.

La Marguerite was captained by John Young, who had previously captained the *St Elvies*. He is seen here on the bridge as the ship approaches Llandudno Pier. *La Marguerite* left the service and was broken up in 1926. A verse written to commemorate her last voyage on 28 September 1925 read:

> We sailed upon you 'Maggie'
> In sunshine and in rain
> But when you turned our 'tummies' up
> We came back in the train.

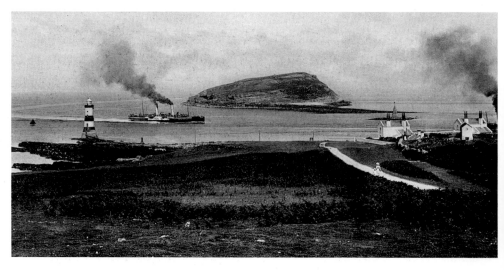

The sound between Puffin Island and Anglesey with *La Marguerite* full steam ahead. This part of the trip was particularly interesting for the sea-bird enthusiast.

LIVERPOOL and NORTH WALES

Easter Sailings Good Friday to Easter Monday, April 10th to 13th, Daily commencing 23rd May to 21st September, 1936

Turbine Steamer

"ST. TUDNO" or "ST. SEIRIOL"

Leaves Liverpool 10.45 a.m. for Llandudno, 4 hours ashore, and Menai Bridge, 1 hour ashore, weather, etc., permitting, due back 7.30 p.m.

Bangor or Beaumaris passengers with Single or Period Tickets proceed from Menai Bridge, Post Office Square, Free Bus conveyance.

FARES	Single		Day	Period
	1st	2nd		
LIVERPOOL TO LLANDUDNO ...	6/-	4/6	6/-*	8/-*
LIVERPOOL TO MENAI BRIDGE	7/6	6/-	8/-*	10/-*

* 1st Class 2/- extra

**Half-day Sailings certain Wednesdays, Saturdays and Sundays.
Llandudno 4/-, 1st Class 5/-.**

Through bookings from Principal Railway Stations, also Interchange Rail and Boat Tickets

Special Boat Fares for Parties of 8 or more, including Free Pass for Promoter of Parties exceeding 25 in number

FREQUENT DAY TRIPS from LIVERPOOL

Round the Isle of Anglesey—170 miles sail (see Bills)

Daily from Llandudno at 1.15 p.m. to Menai Bridge, and on certain Tuesdays to Douglas, also frequent Excursions Round the Island of Anglesey (see Bills).

Morning, Afternoon and Evening Sea Cruises, also occasional Day Trips to Caernarvon from Llandudno by new Motor Vessel " St. Silio.'

EXCELLENT CATERING ON BOARD

Contracts from **21/-** Official Guide **2d.** Post Free

For conditions of Carriage and all further particulars apply to

THE LIVERPOOL AND NORTH WALES STEAMSHIP CO. LTD.

40 CHAPEL STREET, LIVERPOOL.

Tel. 1654 Central. T. G. BREW, Secretary.

Advertising poster for *St Tudno* and *St Seiriol* steamers, 1936.

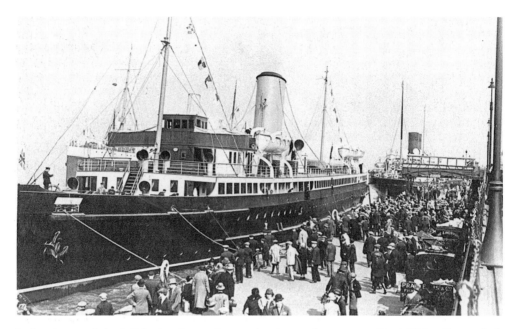

In this photograph the *St Tudno III* is leaving Liverpool on her maiden voyage to North Wales. She was built in 1926 and replaced *La Marguerite*. She was not regarded with the same affection but maintained the high quality established by her predecessor.

St Tudno III was 329 ft long, with a beam of 44 ft and a gross tonnage of 2,326. She was built by the Fairfield Shipbuilding and Engineering Co. of Govan. She was certified to carry 2,493 passengers. The *St Tudno* experienced great difficulty in manoeuvring alongside the piers at Beaumaris and Bangor, and consequently had to stop calling there.

In 1931 the *St Tudno* was joined by her sister ship the *St Seiriol II*, seen here under Telford's Menai Suspension Bridge. The *St Seiriol* did valiant service during the Second World War and played a big part in the evacuation at Dunkirk; in all she returned to the beach seven times and suffered only superficial damage. Throughout the war the Liverpool and North Wales steamers served as minesweepers and troop carriers.

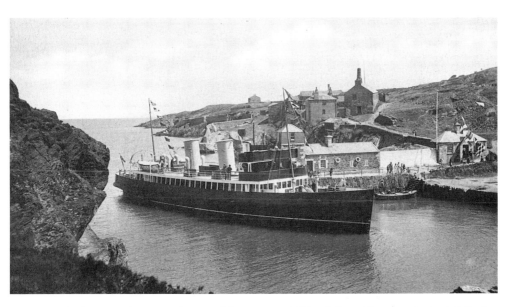

Entering Amlwch Port is the *St Silio*. She started the service in 1936 and changed her name to the *St Trillo* after the war. She was by far the smallest of the ships in the company, with a length of 149 ft and a breadth of 27.1 ft; gross tonnage was 314, and she was licensed to carry 568 passengers. The *St Silio* completed her maiden voyage into Wales on 27 May 1936. After war service she returned on 19 May 1946. The service came to an end in the 1960s after 150 years. The *St Seiriol* was broken up in March 1963 and the *St Trillo* in 1969.

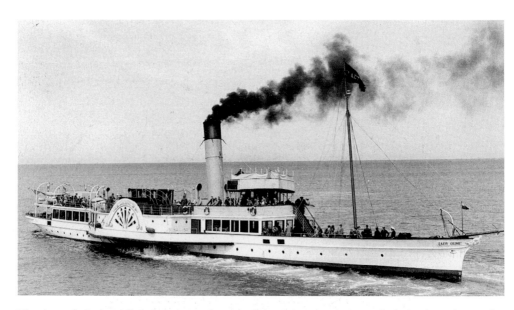

This elegant little ship called *The Lady Orme* began her life as *The Fusilier* in 1888. She had a clipper bow with a figure head, but was not a large ship: length 202 ft, beam 21 ft, gross tonnage 251. She appeared on the North Wales Coast in 1935, owned by the Cambrian Shipping Company of Blackpool, and running an excursion service between Llandudno and Menai Bridge. Her stay was a brief one, 1935–6. She returned in 1937, owned by the Orme Cruising Company, and briefly as *The Crestawave* in 1938. The ship was broken up in 1939.

PEOPLE & EVENTS

George Robert Thompson, c. 1920. The self-styled 'postcard king' was a very well-known Llandudno personality. He had four shops in Llandudno, one shop in Deganwy and a kiosk on the pier.

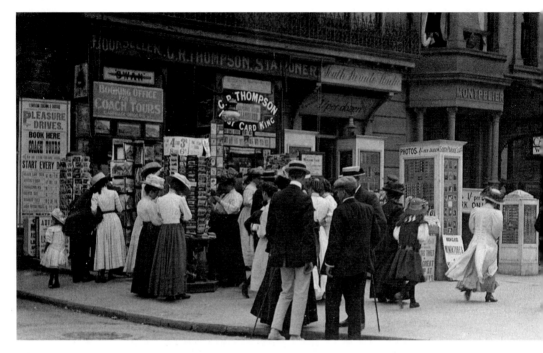

These two photographs show Mr Thompson's shop, at 15 South Parade. The shop sold confectionery, tobacco and stationery. In addition to selling postcards published by others, he himself produced original cards – many of which are included in this book. He died in 1929 and his grandson continued the business until 1985.

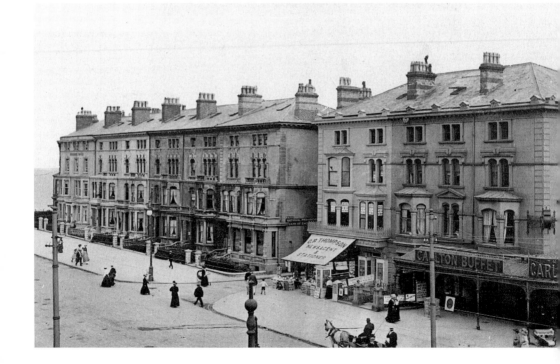

Llandudno May Queen, 1903. In addition to the crowning of the May Queen the celebrations involved a procession through the town with decorated floats, bands and dancers. This was followed by maypole dancing and picnics in the Happy Valley.

Miss Effie Cooper was Llandudno's Rose Queen in 1932.

The first fire brigade in Llandudno was a five-man volunteer force formed in 1854. In 1874 a movement was started to upgrade this vital service and in 1877 a horse-drawn Merryweather hand pump was established in Market Street. In 1882 the hand pump was replaced with a steam pump called the 'St Tudno'. In 1925 it was replaced by the petrol-driven engine shown in this photograph.

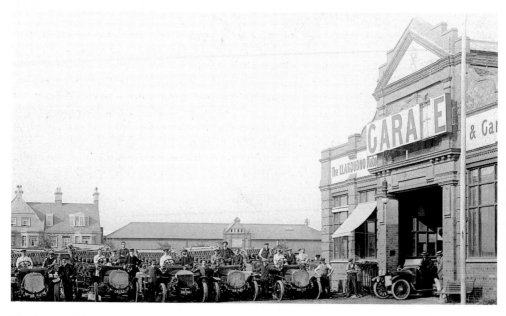

The drivers of the Red Garage, Llandudno, display the five charabancs which make up their luxury fleet, *c.* 1910. The garage opened in 1907 and was originally called the Llandudno Motor and Garage Company Limited. In 1911 Mr Frank Wilkes came to manage the business, and he was there until his death in 1958.

At the end of the last century Llandudno Swifts, seen here in 1899, were a force to be reckoned with in North Wales Association Football. In the season of this photograph they won the North Wales Senior Cup, and had been North Wales Coast League Division 1 Champions in 1896/7 and 1897/8. The first reported football match in Llandudno was in 1875 when Thomas Williams' newspaper *The Directory* said the local team had lost 2–0 to Conway. It was a rough game by all accounts, with a referee who had an idiosyncratic view of the offside laws. 'Pel Droed' (Welsh for 'football') was the pen name of the journalist who wrote the accounts for the *Directory*.

The first team of any significance in Llandudno was Gloddaeth Rovers, which was formed in 1880. They played well for many seasons and spawned one player of international repute: Hersee kept goal for Wales and was also a Llandudno hotelier. In 1891 the Rovers merged with the Swifts, which had originally been a workmen's team. The Swifts played and drew 2–2 with Everton, and in 1895 they played and beat Liverpool 2–1. Unfortunately professionalism reared its ugly head, much to the chagrin of Pel Droed. He wrote of sport in general: 'Football and Cricket have lost their greatest charm since the introduction of paid gladiators and Limited Companies; the Swifts had far more respect in the old days.' These strangely prophetic words were written almost one hundred years ago! In 1900 the Swifts left the Combination with Pel Droed's approval, who said: 'The combination created professionals. We look forward to amateur club lads playing for the love of the game.' The club's giant-killing days were not over however, and in 1901 they played and beat Wolverhampton Wanderers.

In 1929 this Llandudno Football Club team won the North Wales Coast Amateur Cup.

Edward, Prince of Wales, later Edward VII, arrives at Llandudno station, April 1899. Vast crowds thronged the streets for his visit. The Royal entourage drove in an open landau down Vaughan Street and on to the Promenade.

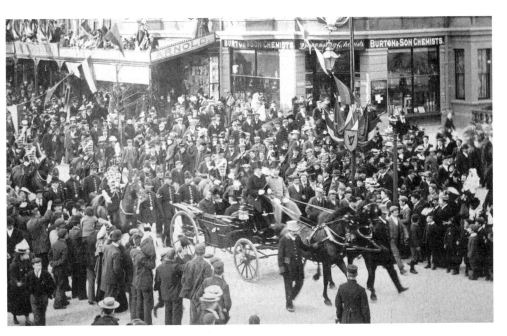

After a concert at the Pier Pavilion the open-topped landau returned to the station via North and South Parades and Mostyn Street. Edward was crowned King in 1901. On a later visit to North Wales, in 1907, he laid the foundation stone for Bangor University.

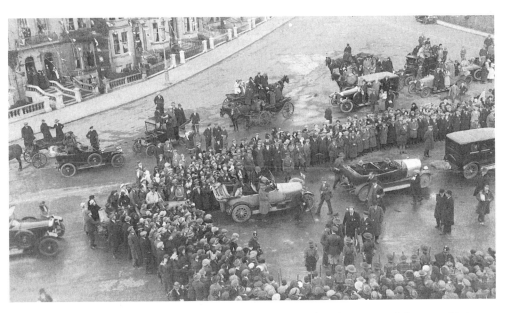

In November 1923 HRH Prince Edward, Prince of Wales (later Edward VIII) visited the town. He is seen among the crowds approaching the Cenotaph in Prince Edward Square. The war memorial had been unveiled a year before, in 1922. The ex-servicemen formed a guard of honour, and the crew of the lifeboat raised their oars in salute to the Prince, who was President of the Lifeboat Institution.

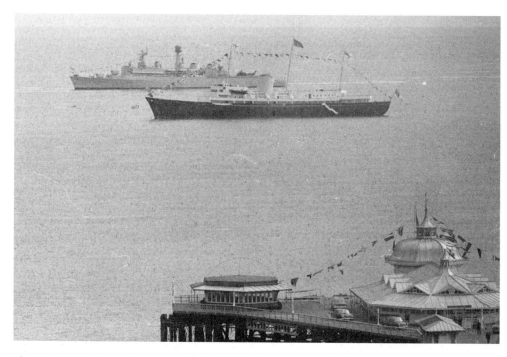

The Royal Yacht *Britannia*, accompanied by HMS *Glamorgan*, visited Llandudno on 2 July 1969. Prince Charles disembarked and visited the town on the day after his investiture as Prince of Wales in Caernarfon.

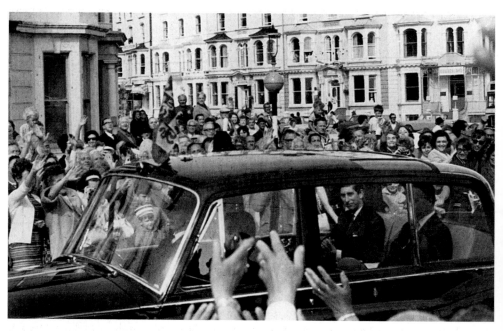

HRH Prince Charles had been Prince of Wales for a day on his visit to Llandudno. The highlight of the celebrations for the town was the pageant 'Llandudno Regina'.

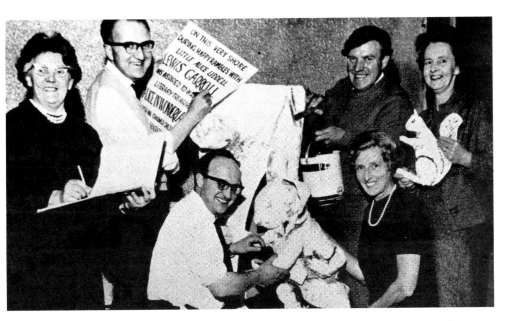

It is 2 July 1969, and the town is celebrating the investiture of Prince Charles with a performance of a pageant entitled 'Llandudno Regina – The Story of Llandudno told in Song, Music and Dance'. This photograph shows some of the very important back stage production workers. Left to right: Miss Alex Spinks, Mr David Sandbach, Mr Gwynne Evans, Mrs Marion Pierce, Mr Ron Davies, Mrs Molly Humphrey Smith.

With 300 people involved in the seventeen episodes in the 'History of Llandudno' many costumes were required. The sewing guild had a very important part to play. The members of the guild shown here are: Standing, left to right: Mrs R. Tingle, Miss J. Jones, Mrs N. Harvey, Mrs H. Smith, Mrs G. Lewis. Seated: Miss C. Davies, Mrs E. Ogle, Mrs E. Williams, Mrs E. Davies, Miss L. Chidler.

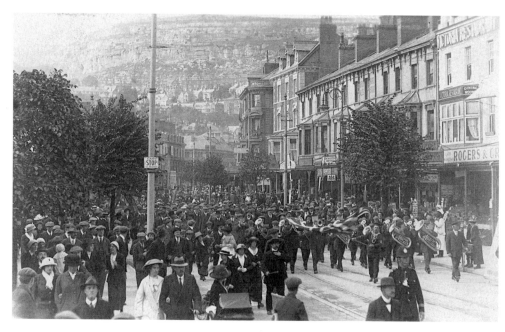

A recruitment parade passing through Mostyn Street, 1915. Leading the parade is a sailor twirling a Union Jack, and he is followed by the town band. The parade ended in a meeting where passionate patriotic speeches were made urging young men to volunteer for the fields of France.

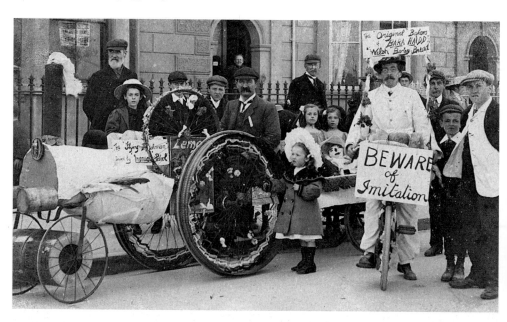

A tableau from a May Day Parade in the early years of the century. The photograph shows 'The Flying Dutchman' driven by 'Manual Petrol' complete with seagull's wings. The float was sponsored by T. & R.D. Jones, grocers. The man on the bicycle is advertising 'Bara Haidd' Welsh barley bread, and urging his customers to beware of imitation.

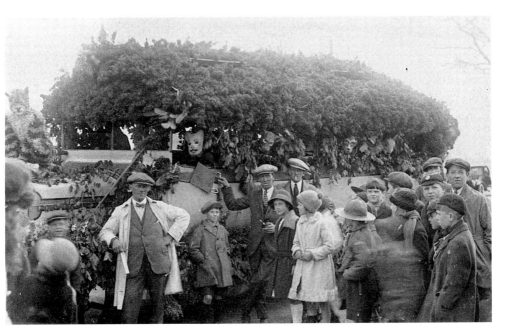

Llandudno's May Day Procession, 1924. The charabanc is exhibiting its first prize certificate for a display involving the cartoon character Felix the Cat who kept on walking. May Day celebrations had a long tradition in Llandudno; the first was held in 1892, and they continued until the 1950s.

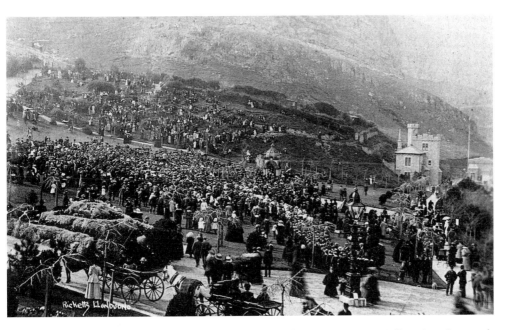

This photograph of 1910, taken by Rickets of Llandudno, is the scene in Happy Valley when the crowds gathered to hear that George V had been proclaimed king. This scene was repeated in all the public gathering places throughout the United Kingdom.

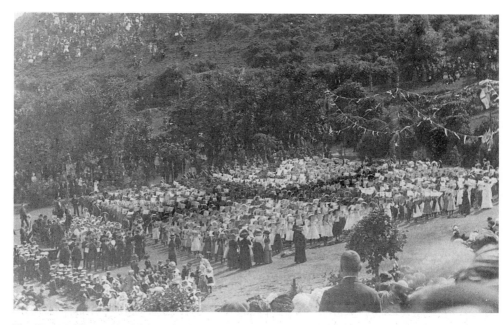

This Happy Valley scene celebrates the Coronation of King George V, who succeeded his father Edward VII in 1910. In this photograph the girls in their white dresses form the corners, and others in darker clothes form the cross in a living depiction of the flag of St George.

Dyffryn Road School, with the children dressed in their Sunday best, c. 1908. The needs of the expanding town put pressure on the Lloyd Street School and a new council school was built in Dyffryn Road in 1905.

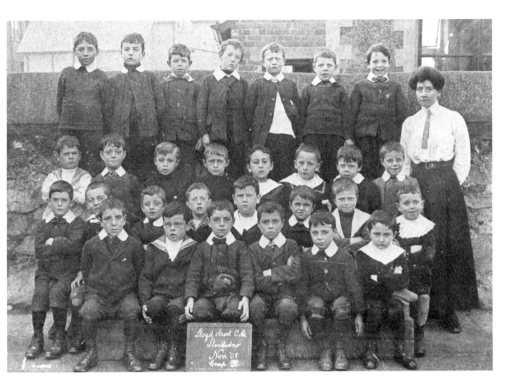

Group 5 of Lloyd Street School, November 1906. It would appear that the sexes were segregated for instruction at this time as this is an all-boys group. The school was built after Forster's Education Act of 1870 legislated for the universal provision of elementary education. Lloyd Street School was opened in 1882 in response to pressure by HM Inspectors. The foundation stone was laid in 1881 by John Bright, the great Liberal dissenter. In 1847 an inspector's report highlighted a controversy which still exists – the place of the Welsh language as a medium of instruction in Welsh schools. The report stated that out of 200 children questioned only about 10 could answer questions in English. If a similar survey were conducted today it is likely that only a small minority could answer questions in Welsh, although in recent years there has been a welcome increase in Welsh teaching in the local schools.

A class of 1935 in Craig-y-Don School, which was built at the turn of the century as a Board School in response to rapid expansion in this part of the town. Craig-y-Don School became a designated Council School under the control of the County Education Authority as a result of the 1902 Education Act. The school is now a Community Centre.

Llandudno Gasworks tug of war team, 1912. They were the proud possessors of several trophies. The gasometer was in evidence on all early photographs and postcards, as it was built in 1857. The biggest gasometer in North Wales was built in 1899 and demolished in 1958. In 1995 the last of Llandudno's gasometers was removed from the works and the site is now used for the storage of liquid gas.

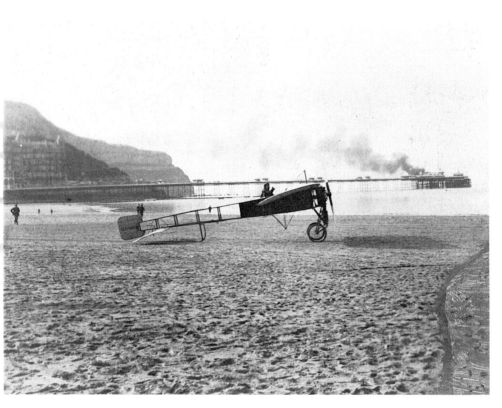

An early flying machine on Llandudno beach. The message on the back describes it simply as 'Blériot'. Blériot flew the English Channel in 1909, so it is possible that this is him.

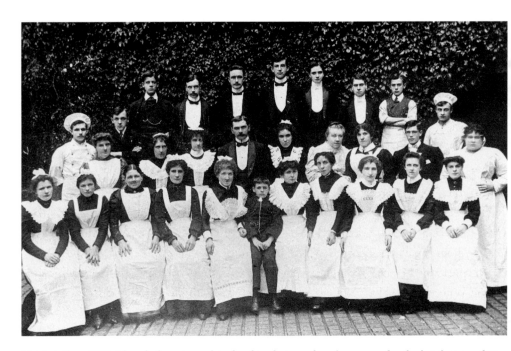

Hotel staff, *c.* 1912. Though there is no date for this photograph and no name for the hotel, it is a fitting photograph with which to end a book on Llandudno. The people shown here, and many thousands like them since it was taken, have been the backbone of the economy of Llandudno since the establishment of the town as 'Wales' Premier Seaside Resort' at the end of the last century.

ACKNOWLEDGEMENTS

G rateful thanks are due to the following people for their help in the preparation of this book: Douglas Baxter, Derek Blamire, John Cowell, Mike Day, Mike Hitches, Brian Hurst, David Hughes, Freda Mealing, Bill Oliver, Robert Owen, Gwyneth Smith, Peter Thompson, and the staff of the Llandudno Library.

Previous writers who have informed and inspired are Ivor Wynne Jones, Michael Senior, F. Ron Williams, Aled Eames, John Cowell, Don Smith, Keith Turner, Eifion W. Roberts, Mike Hitches, Mary Aris and Ian Skidmore.

Other titles published by The History Press

A Century of Llandudno
JIM ROBERTS

This fine selection of photographs illustrates the transformation that has taken place in Llandudno during the 20th century, offering insight into the daily lives and living conditions of local people during a century of change.

£9.99 978 0 7509 4936 1

Around Mold
DAVID ROWE

This fascinating new book presents some of the events and people who have made up the life of the historic Welsh market town of Mold.

£12.99 978 0 7509 4947 7

A History of Magic and Witchcraft in Wales
RICHARD SUGGETT

The untold history of Welsh Witches and Wizards and how they were tracked down by a vengeful community.

£17.99 978 0 7524 2826 0

Discovering the Smallest Churches in Wales
JOHN KINROSS

A small church nestling deep in the countryside is instantly evocative. Why is it there at all? Whom does it serve? This companion volume to the author's successful 'Discovering the Smallest Churches in Wales' covers almost 50 churches in Wales which have naves of 30ft or less.

£12.99 978 0 7524 4101 6

Visit our website and discover thousands of other History Press books.
www.thehistorypress.co.uk